JANET KIME

It's Raining Cats & Dogs

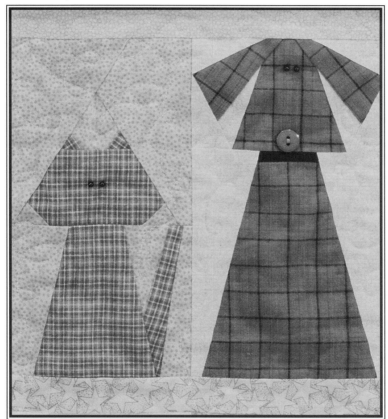

PAPER-PIECED QUILTS FOR PET LOVERS

Martingale
& COMPANY

BOTHELL, WASHINGTON

Acknowledgments

Without the help of my many quilting friends, this book would not have been possible. Special thanks to my sister, Karen Gabriel, and my best quilting buddy, Virginia Morrison. Thanks also to Carolyn Bohot, Sue Bower, Lorraine Herge, Marian Johnson, Jo Kautz, Nancy Noerpel, Jolene Otter, and Lois Shevlin.

CREDITS

President . Nancy J. Martin
CEO/Publisher . Daniel J. Martin
Associate Publisher . Jane Hamada
Editorial Director . Mary V. Green
Design and Production Manager Cheryl Stevenson
Technical Editor . Dawn Anderson
Text and Cover DesignerTrina Stahl
Copy Editor . Liz McGehee
Illustrator . Lisa McKenney
Photographer . Brent Kane

That Patchwork Place, Inc., is an imprint of Martingale & Company.

MISSION STATEMENT

We are dedicated to providing quality products and service by working together to inspire creativity and to enrich the lives we touch.

It's Raining Cats and Dogs
© 1998 by Janet Kime
Martingale & Company, PO Box 118, Bothell, WA 98041-0118
USA

Printed in the United States of America
03 02 01 00 99 98 6 5 4 3 2 1

Library of Congress Cataloging-in-Publication Data
Kime, Janet,
It's raining cats and dogs : paper-pieced quilts for
pet lovers / Janet Kime.
p. cm.
ISBN 1-56477-242-X
1. Patchwork—Patterns. 2. Patchwork quilts. 3. Cats in art.
4. Dogs in art.
TT835.K49537 1998
746.46'041—dc21 98-30032
 CIP

Contents

Introduction • 4

General Directions • 4

FABRIC SELECTION • 4

FOUNDATION PIECING • 5

Assembling Sections • 6

Reversing Designs • 8

Enlarging Designs • 8

ROTARY CUTTING • 8

SPEED PIECING • 9

ASSEMBLING THE QUILT TOP • 9

Staystitching • 9

Assembling the Blocks • 10

Adding Borders • 10

Making the Quilt Backing • 10

Basting the Quilt • 11

QUILTING • 11

Machine Quilting • 11

Hand Quilting • 11

BINDING • 12

ADDING FACES AND
OTHER DETAILS • 13

Quilts • 14

Kittens and Mittens • 14

Meow Mix • 33

Charles's Quilt • 37

Mutts and Friends • 41

My Funny Valentine • 46

Angus in Plaids • 53

Lucifer and Friends • 57

Tryst • 62

Fetching • 66

In the Doghouse • 70

WildCats • 77

Chasing the Ball • 82

Sit Up and Beg • 86

Linus and Samantha • 90

Hanging BasKats • 96

Angels Who Meow on High • 102

Little Angels • 107

Gallery of Quilts • 17

About the Author • 112

Introduction

THIS BOOK IS a collection of ten cats and four dogs, all foundation-pieced on paper patterns. Most of the designs are incorporated into two quilts: one quilt with complete directions in the book, and the other showing the design in different colors with a different arrangement of the blocks. In most cases, the second quilt is so simple that most quilters could duplicate it without directions. Where it seemed to be a good idea, directions for both quilts are included.

Although the designs are presented in approximate order from the most simple to the more challenging, none of the designs is difficult. The beauty of foundation piecing is that even beginning quilters can assemble designs with many small pieces and odd angles—all you have to do is stitch on the lines.

When I first started foundation piecing, I avoided any pattern that was assembled in sections. When I finally encountered a sectioned design I couldn't live without, I discovered that assembling sections isn't difficult at all. When you sew one section to another, you are just making a seam, and we know how to sew seams. Some of the designs in this book have as many as five sections. Don't worry about them. Just follow the numbers and stay on the lines, and you'll be fine.

This book has one feature you haven't seen before—tips on how to design your own foundation-pieced patterns. Many of the designs are easily modified by moving the lines slightly to make the cats and dogs fatter or thinner, or their ears or tails larger or smaller. In one case, that is just what I did, and patterns for several variations of the basic designs are included in the book. If you've always wished you could make up your own block designs, you'll enjoy individualizing the patterns so they look more like—and reflect the personalities of—your own furry friends.

This is not a book to make you sweat and struggle, or to inspire you to spend two years making an heirloom quilt. This is a book for when you want to kick back and make something silly.

Have fun!

General Directions

Fabric Selection

In general, foundation piecing works best with 100%-cotton fabrics. Blends are more difficult to work with; they are slippery, they often are not tightly woven so they warp out of shape, and they don't press with a sharp crease.

Because the individual pieces are often small, most of the designs in this book are best made with solid fabrics or small prints. Large-scale prints can be effective, as long as they contrast well with your background fabric so the edges of the design are clear; if they aren't, it may be difficult to tell that your cat is a cat.

Directional fabric, such as plaids and stripes, should also be used with care. In traditional piecing, you cut the fabric pieces before you sew, so you

can carefully align directional prints. In foundation piecing, there are often many small pieces, and they are cut to shape after they are sewn, making it difficult to control the direction of a print. The dogs and cats of "Mutts and Friends" (page 21) are good ones for directional prints, as each section starts with one large piece of fabric that can easily be aligned.

Foundation Piecing

In foundation piecing, fabric pieces are added, one by one, to a design drawn on a paper foundation. All seams are sewn directly on the drawn lines, through the foundation. The beauty of foundation piecing is that you can piece very complicated designs with absolutely no templates. The technique is also useful for miniature designs, where it can be difficult to sew together tiny pieces with accuracy. When you sew the designs on foundation paper, the lines and points of the design are always neat and clean.

For the paper foundation, you can use either tracing paper or regular typing paper. One advantage of tracing paper is that you can see through it, so the drawn design is visible on both sides. It's also lightweight, so it's easy to remove. You can't photocopy onto tracing paper, however, so you must trace each line by hand.

The big advantage to regular paper is that you can quickly make a number of photocopies of your design. Since you can't see through regular typing paper, however, you must often hold the piece up to the light to see through it and position the fabric. It is also a little more difficult to remove the paper after piecing.

Note that foundation piecing has one peculiarity: the block you sew will always be the mirror image of the design on the foundation pattern.

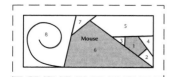
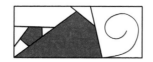

1. Trace the design as accurately as possible on tracing paper, or photocopy it onto regular paper. Draw a ¼"-wide seam allowance beyond the outer edges of the design. Copy the numbers as well; they tell you the order in which the pieces are added. Shade lightly (or mark with an X) the dark areas of the design to indicate which fabric is used in each section. Cut out the foundation, cutting a bit larger than the drawn design plus seam allowances.

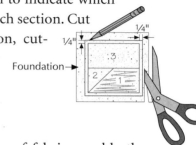

2. Cut a piece of fabric roughly the shape of piece #1 in the design, adding about ¼" all around for seam allowances. Place the fabric piece, right side up, on the wrong (unmarked) side of the foundation.

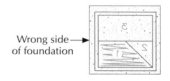

Wrong side of foundation

3. Cut a piece of fabric roughly the shape of piece #2 plus seam allowances. Pin it to fabric piece #1, right sides together. Check that both pieces overlap the seam line by at least ¼".

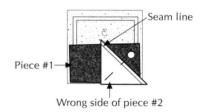

Seam line

Piece #1

Wrong side of piece #2

4. Turn the unit over so the printed side of the foundation is up and the fabric is on the underside. Sew the seam exactly on the drawn line, extending the seam at least ⅛" beyond the drawn line on both ends. Do not backstitch at either end.

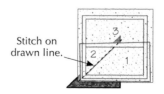

Stitch on drawn line.

5. Turn the unit over so the fabric is on top. Trim the seam allowances to ¼" or less. Flip piece #2, and press with a dry iron.

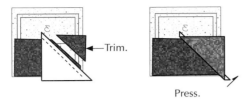

6. Pin piece #3 in place on the wrong side of the foundation, turn the unit over, and sew the seam on the drawn line. Turn the unit over, trim the seam allowances, flip piece #3, and press.

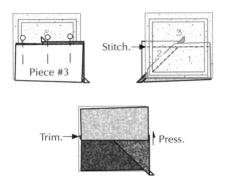

7. Add the remaining pieces in order.

8. The shape of each piece in a foundation-pieced design is often odd, making it difficult to precut the fabric. At first, you may sew and flip and discover that, because of the angle of the seam, the fabric doesn't cover the area it was intended to cover. The easiest way to deal with this problem is to cut the fabric pieces extra large. For many shapes, however, you can prepare the piece of fabric by trimming one edge at an angle that matches the angle of the seam. Hold the paper foundation with the printed side up, and the fabric piece right side down; then trim the fabric.

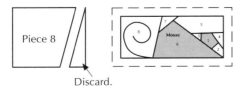

9. When the block is done, trim the edges, leaving ¼"-wide seam allowances. Use the outer dashed lines on the foundation pattern as a guide,

but use a ruler to cut the block to the exact size needed, including ¼"-wide seam allowances. For the moment, leave the foundation paper in place.

Assembling Sections

Many of the blocks in this book are assembled in sections. Each section is foundation-pieced separately, then the sections are sewn together. In all cases, the letters of the section indicate the order in which they should be sewn to each other. For example, in a three-section block, sections A and B are sewn together to make an A/B unit, then section C is added to the A/B unit. In other blocks, smaller sections are sewn to each other and then added to the main section as a unit. For example, in the entwined-tail cats in "Lucifer and Friends" (page 57), the tail sections C and D are sewn together and then added to the cat bodies.

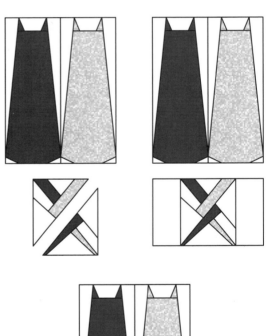

In other designs, piecing starts on one foundation pattern; it is then set aside while other sections are pieced. These sections are sewn to the main foundation pattern; then the remainder of the block is pieced. In "Hanging BasKats" (page 96), for example, the A pieces are sewn to the main foundation pattern. Section B is then pieced and added. Sections C and D are pieced and sewn to each other, then added to the main foundation pattern. Finally, the rest of the main foundation pattern is pieced (section E).

Once you have mastered the basics of foundation piecing, these tips will make the sewing easier and improve your results.

❧ Always press with a dry iron. Steam makes the paper foundation curl and can distort it.

❧ Use a smaller stitch length than usual. The more holes you make in the paper foundation, the easier it will tear away.

❧ Grade the seam allowances as you trim them to reduce bulk: trim one layer first, then trim the other so it is wider or narrower. If one fabric is darker than the other, make the darker seam allowance the narrow one. It will then be less likely to show through on the surface of the quilt.

Common Mistakes

It is easy to make a mistake while foundation piecing, especially when you are in a hurry. Almost all my errors fall into one of these four categories:

❧ *A piece is added out of order.* You may think you know what piece goes next, but it is easy to skip a step. Follow the numbers!

❧ *The wrong fabric is used.* Piece the first block carefully, then pin it up where you can see it and use it as a guide. If you keep making the same mistake, use a pencil to write the names of the colors in their proper places on the foundation pattern.

❧ *The fabric is sewn to the foundation with the wrong side up.* Except for the first piece, every piece should be right side up (facing the paper foundation) as you start to sew. If you are a beginner, try working with solid fabrics—both sides are the right side!

Helpful Hints for Assembling Sections

1. **Pin the sections together, pushing pins through the corners of the design at both ends of the seam line, on both foundation patterns. If there are parts of the design that must match along the seam line, pin them too. See the "Tip" on page 104 for pinning bulky sections.**

2. **After you sew the sections together, trim the seam allowances to ¼". Tear away the paper in the seam allowances only, then press the seam allowances in the direction of least resistance. If there is a lot of bulk, press the seam allowances open.**

3. **If, after you sew the seam, two lines of the design don't quite meet properly, try folding the seam allowances to one side and then the other. Often, the mismatch will look better one way.**

᠍ *A piece of fabric that is too small or not the right shape is used.* You turn the block over to press it, and the fabric doesn't cover the area it was supposed to. Cut the pieces large! Cut them really large for funny-shaped pieces. You have lots of fabric in your collection. I know you do.

REVERSING DESIGNS

Many quilts in this book use both the block and its mirror image. The mirror image of a design is called its reverse. For example, a quilt might call for six cats, three as printed and three reversed. This is sometimes abbreviated as 3 + 3r.

To make the mirror image of a pattern, trace it or photocopy it and then tape the copy to a window, with the right side toward the window. Trace the design, and you have the mirror image.

ENLARGING DESIGNS

Unlike templates with seam allowances, foundation-pieced designs are easily enlarged with a photocopier. Take the foundation pattern to a photocopy shop and ask to have it enlarged. Before you go, determine the enlargement percentage you need. For example, if you have a pattern for a 6" block and you want to make it a 9" block, you need a 150% enlargement.

Rotary Cutting

Some of the quilts in this book include blocks that are rotary cut, rather than foundation-pieced. You will need at least three pieces of equipment: a rotary cutter, a cutting mat designed for rotary cutters, and one or two transparent acrylic rulers.

1. Press your fabric before cutting. Fold it with selvages together and lay it on the cutting mat with the fold toward you.

2. If you don't have a second ruler, place the folded edge on one of the grid lines on the mat. Then line up your long ruler with a vertical grid line so that the ruler just covers the raw edges of the fabric.

If you have a second ruler, place it close to the left edge of the fabric and align the edge of the ruler with the fold. Lay the long ruler next to the short ruler so that it just covers the raw edges of the fabric, then remove the short ruler. Cut the fabric with the rotary cutter, rolling the blade away from you, along the side of the long ruler.

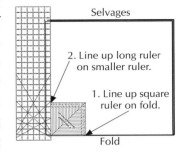

This first cut is called a clean-up cut. It tidies the edge of your fabric and ensures that the next cut will be exactly perpendicular to the fold. If the cuts are not perpendicular to the fold, when you open the strip, it will have a dogleg instead of being perfectly straight. Recheck the angle of the ruler after every two or three cuts and make another clean-up cut whenever necessary.

3. After you have tidied up the edge of the fabric, you are ready to cut the pieces for your quilt. Align the required measurement on the ruler with the newly cut edge of the fabric. Cut strips across the width of the fabric, from selvage to selvage, in the required width.

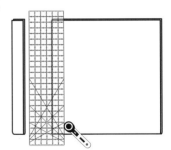

To cut squares:

Cut strips in the required widths. Trim away the selvage ends of the strip and crosscut into pieces of the desired size. For example, if your design calls for 4 squares, each 4" x 4", cut a 4"-wide strip across the width of the fabric, trim off the selvages, then make 2 crosscuts, each 4" wide.

Speed Piecing

Speed piecing is a combination of rotary cutting and shortcut sewing techniques. Many speed-pieced designs require a strip unit, which is made by sewing fabric strips together lengthwise. The strip unit is pressed and crosscut into segments. The crosscuts are then sewn together to make a design.

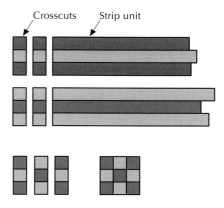

Crosscuts Strip unit

1. Sew the strips together carefully, with exact ¼"-wide seams, so all the finished strip widths are equal. The unit must also be straight; if the bottom fabric feeds into the sewing machine faster than the top fabric, or vice versa, the unit will curve. To combat this tendency, sew pairs of strips together from top to bottom; then sew the pairs to each other, bottom to top.

2. Press the strip unit carefully so that it lies perfectly flat, with no pleats at the seams. The pattern instructions will tell you which direction to press the seam allowances. Press the wrong side first, then flip the unit over and press the right side, pushing the broad side of the iron into the bump at each seam to flatten it.

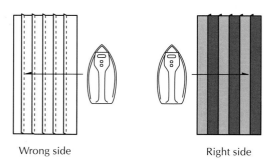

Wrong side Right side

If the unit curves just slightly, you may be able to steam it back into line. If not, make frequent clean-up cuts as you crosscut. The crosscuts must be perpendicular to the seam lines, or the little squares will not be square.

Assembling the Quilt Top

STAYSTITCHING

Paper foundations, especially if you use regular typing paper, seem bulky and stiff if you aren't used to them. It is tempting to remove the paper as soon as the block is pieced. There are always bias edges around the outside of the block, however, and if you remove the paper too soon, the edge of the block can stretch out of shape.

You can solve this problem by staystitching the outer edges of the block after you trim the block to size, but before you remove the foundation paper. To staystitch, machine stitch around the block ⅛" from the outer edges.

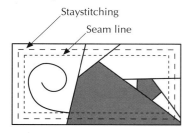

Staystitching

Seam line

Always remove the paper right after you staystitch, before you sew the block to another block. If you leave the paper in, you will have a ⅛" strip of paper between the stitched seam and the staystitching, and it will be difficult to remove.

In this book, the directions for each quilt suggest the best time to staystitch and remove the foundation paper. Often, this occurs after each row of blocks is stitched together. The paper is usually not in the way up to this point, and it takes less time to staystitch around each row than it would to staystitch around each block. In small quilts or quilts made with tracing-paper foundations, you may be comfortable leaving the paper in until after the borders are on, so no staystitching is necessary.

ASSEMBLING THE BLOCKS

Sewing quilt blocks together into a quilt top is called setting the quilt. The blocks can be arranged either in a straight set or a diagonal set.

For a straight set, sew the blocks together into rows, then sew the rows together.

Straight set

For a diagonal set, set the blocks "on point" and sew them together into diagonal rows. Add triangles to the end of each row to square up the quilt.

Set on point

Sashing

Sashing strips are strips of fabric sewn between the blocks. The strips isolate the blocks, making the individual design of each block easier to see. Sashing strips are added as the blocks are sewn together. Short strips are sewn between the blocks in each row, then long strips are sewn between the rows as they are sewn together. Some quilts have cornerstones, which are little squares where the sashing strips intersect.

ADDING BORDERS

The border frames the quilt design and contains it. A border can be made from plain fabric strips, or it can have elaborate pieced designs. Almost all the quilts in this book have straight-cut borders.

For a simple straight-cut border, sew border strips to the sides of the quilt and press, then sew strips to the top and bottom.

Straight-Cut Border

Or, sew border strips to the top and bottom of the quilt and press, then sew border strips to the sides.

Although there will probably be little variation in the size of your foundation-pieced blocks, it is still wisest to measure the quilt and cut the sashing and border strips to match. Often the directions suggest that you cut the strips before you begin to foundation-piece and give the exact measurements. Cut the strips generously long and trim them to the lengths needed to match your quilt just before you add them. Measure the length and the width in two or three places toward the center of the quilt, rather than along the edges.

MAKING THE QUILT BACKING

Backings for small quilts can be cut from a single piece of fabric. Be sure to trim off the selvages, which can draw in the edges and prevent the back from lying flat.

Although there are some 90"-wide fabrics available for quilt backings, usually you will piece the backing for a quilt wider than 40". For quilts up to 80" wide, simply piece two lengths of fabric together with a long center seam. For a quilt 50" to 60" wide, you might want to add a contrasting fabric strip or pieced blocks to one side of the quilt back, or cut the main piece of fabric in half lengthwise and add a strip to the center. Seams in quilt backings are usually pressed open to reduce bulk.

Pieced Quilt Backings

Basting the Quilt

Purchase packaged batting intended for hand or machine quilting. Take it out of the package the night before to allow it to relax. Steam out any wrinkles.

1. Lay the quilt backing on the floor, wrong side up. Smooth out all wrinkles. Use masking tape around the edges to hold the backing in place.

2. Lay the batting on top of the quilt backing, smoothing out any wrinkles. Smooth the quilt top over the batting and pin through all the layers here and there around the edge.

3. Crawl around on the quilt and hand baste the layers together with 1" stitches, in horizontal and vertical lines about 3" apart. Always baste with white thread; colored thread may leave little colored dots. Also baste all around the quilt about ¼" in from the edge; this will hold the edges together when you add the binding later.

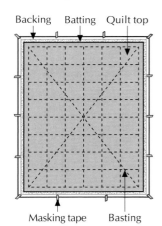

Backing Batting Quilt top

Masking tape Basting

4. If you plan to machine quilt, you may choose to baste your quilt with safety pins rather than basting stitches. Fasten the pins about 3" apart, avoiding the lines along which you plan to quilt.

Small quilts can be basted on a tabletop. I recommend investing in a large piece of white foam-core board, available at art-supply stores. It's inexpensive, lightweight but rigid, and you can pin your quilt to it for basting.

Quilting

Quilting is the stitching that holds together the backing, batting, and quilt top. Foundation-pieced designs are often machine quilted, as they tend to have many seams that are difficult to cross with hand quilting. Also, you cannot press the seam allowances one way or another to accommodate hand quilting. If you prefer hand quilting, try quilting ¼" away from the design to avoid seam allowances, or fill in the background areas between design elements with hand quilting.

Machine Quilting

Machine quilt with regular sewing thread or with the thin nylon thread made for machine quilting. If you use nylon thread, use regular thread in the bobbin. Set the machine for a stitch slightly longer than you use for regular sewing. Roll up the parts of the quilt you aren't working on to keep them out of the way. Whenever possible, start and stop at the edges of the quilt and backstitch for security; the ends will be covered by the binding. When you must start and stop in the middle of the quilt, leave 4" thread ends. When you are finished, thread each end on a needle, pull it inside the quilt through the batting, and trim on the quilt surface.

Hand Quilting

1. Place the basted quilt in a hoop or quilting frame. Start in the center of the quilt and quilt in sections toward the edges, moving the hoop as necessary. Use short quilting needles called "Betweens" and the heavy thread sold as hand-quilting thread. You will also need a quilting thimble, which is like a regular thimble except that it is indented on the end rather than rounded.

2. Tie a small knot in the end of the thread. With the needle, wiggle a hole in the surface of the quilt about ½" from the place you plan to start quilting. Push the threaded needle in through the hole and back out on top of the quilt where you plan to start, pulling the knot through the hole so it is buried in the batting. There should be no knots

showing on either the top or the bottom of the quilt.

3. Quilt with a running stitch. Use the quilting thimble on your third finger to push the needle through the quilt, rocking the needle up and down to help make the stitches smaller.

4. When you reach the end of your thread or a stopping place in your design, tie a knot in the thread, pull the knot into the batting, and cut the thread even with the surface of the quilt.

Be sure stitches go through all three layers.

Binding

Finish the edges of your quilt after you have quilted it, as quilting tends to pull it up and make it smaller. Most of the quilts in this book were finished with ½" straight-grain, double-fold binding.

To make ½" binding:

1. Cut strips from the binding fabric 2¾" wide. Cut enough strips to go around the quilt plus about 20" for joining strips and turning corners.

2. Join the strips at right angles with a diagonal seam as shown. Trim away any excess, leaving a ¼"-wide seam allowance. Press seams open.

3. Trim one end to a 45° angle and press under ¼". Fold the strip in half lengthwise, wrong sides together, and press.

4. Trim the quilt so that the batting and backing extend ¼" beyond the raw edge of the quilt top. Machine sew the binding strip to the right side of the quilt, right sides together. Match the raw edges of the binding with the edges of the quilt top (not the edge of the batting and backing) and take a ¼" seam. Start with the end cut to a 45° angle. Stop the seam at each corner ¼" from the edge of the quilt top; backstitch.

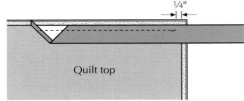

5. At the corner, fold the binding strip away from you and then back toward you as shown, lining up the fold with the top edges of the batting and backing, and the raw edges of the binding with the edges of the quilt top. Start sewing the next side at the edge of the fold, backstitching. Repeat at each corner.

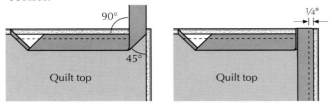

6. Stitch the binding all around the edge of the quilt, overlapping the beginning of the binding strip by 1".

7. Fold the binding to the back of the quilt and hand stitch down. At each corner, a miter will form automatically on the front of the quilt; fold the binding to make a miter on the back. Where the beginning and the end of the binding strip overlap, hand stitch the join.

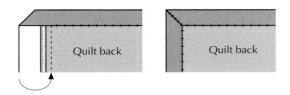

To make ¼" binding:

Cut the strips 1¾" wide. Trim the batting and backing even with the raw edge of the quilt top. Attach binding in the same manner as described for ½" binding.

STRAIGHT-CORNER BINDING

If you don't want to miter the corners of the binding, trim the quilt as described on page 12, step 4, and sew the binding strip to the sides of the quilt, right sides together, matching the raw edges of the binding strip to the edge of the quilt top and taking a ¼" seam. Trim the binding even with the batting and backing at each end. Fold the binding to the back of the quilt and hand stitch in place.

Quilt front
(already quilted)

Sew the binding to the top and bottom edges of the quilt. Turn under ¼" at each end; blindstitch the ends closed.

Adding Faces and Other Details

You may want to add eyes, noses, and whiskers to your cats and dogs. Features can be embroidered with two or three strands of embroidery floss.

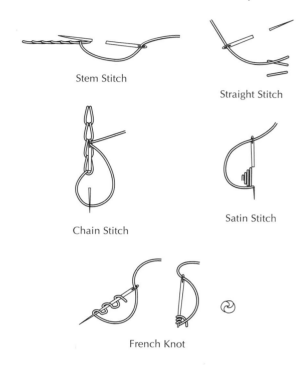

Stem Stitch

Straight Stitch

Chain Stitch

Satin Stitch

French Knot

Fabric paint is a fast alternative to embroidery. I like the fabric paint that comes in little squeeze bottles; it is thick enough to make a round, shiny dot for an eye.

Beads also make good eyes. The quilts in this book use small beads, either seed beads or 3mm beads, available from craft-supply houses. Sew the beads on after the quilt is completed, sewing through all layers.

To create faces, such as the ones in "My Funny Valentine" (page 17), "Meow Mix" (page 18), and "The Cats in Red Square" (page 18), it is helpful to use a stencil as a guide. You can cut a stencil from template plastic, using an X-Acto knife. Paint the faces with stencil paint and a stencil brush, or draw them on with a fine-tip permanent pen. Either way, the stencil helps keep the lines straight.

Kittens and Mittens

Each kitten has a pair of matching mittens, connected by a quilted "idiot string."

Color Photo: page 26
Quilt Size: 17" x 20"
Finished Block Sizes
 Kittens: 3" x 4"
 Mittens: 1¹/₂" x 1³/₄"

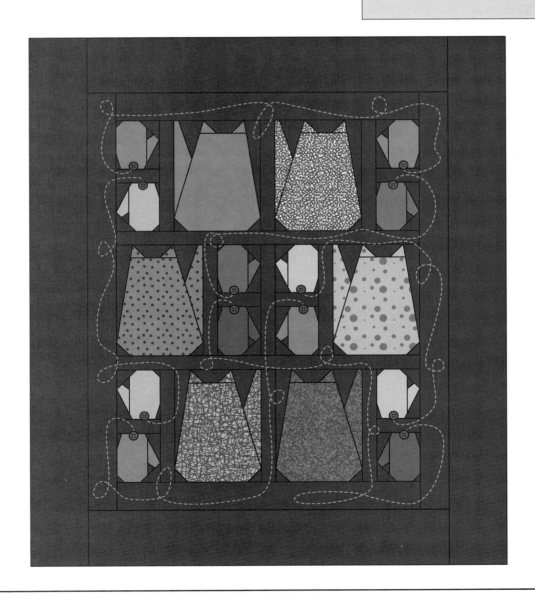

Fabric	Piece	No. of Pieces	Dimensions
Background	Mitten sashing	6	1" x 2"
	Vertical sashing	9	1" x 4½"
	Horizontal sashing	2	1" x 11"
	Top and bottom inner border	2	1½" x 11"
	Side inner border	2	1½" x 15½"
	Top and bottom outer border	2	2½" x 13"
	Side outer border	2	2½" x 19½"

MATERIALS: *42"-wide fabric*

¼ yd. total OR scraps for kittens

Scraps of 6 different fabrics for mittens

1 yd. for background, borders, and binding

¾ yd. for backing

12 buttons, ¼" in diameter, in matching pairs

CUTTING

NOTE: Referring to the chart above, cut the sashing and border strips from the background fabric first, then use the remaining fabric to foundation-piece the blocks.

PIECING THE BLOCKS

Refer to "Foundation Piecing" on pages 5–8. Use the patterns on page 16. Press all seam allowances in the direction of the arrows unless otherwise instructed.

1. Foundation-piece 6 kittens, 3 plus 3 reversed.

2. Foundation-piece 12 mittens, 1 plus 1 reversed from each of 6 different fabrics.

ASSEMBLING THE QUILT TOP

1. Following the quilt diagram, arrange the Kitten and Mitten blocks. Make sure each pair of mittens matches a pair of mittens in the illustration.

2. Sew each unit of 2 mittens together, adding a 1" x 2" strip of mitten sashing between the mittens.

3. Sew the 3 rows of kittens and mittens, adding a 1" x 4½" strip of vertical sashing fabric between each unit as shown.

Make 6.

4. Join the 3 rows, adding 1" x 11" strips of sashing between the rows.

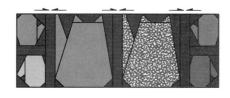

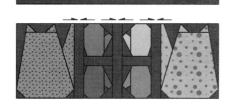

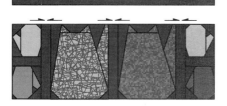

5. Sew the inner border strips to the top and bottom first, then to the side edges of the quilt top; press the seam allowances toward the inner border.

6. Sew the outer border strips to the top and bottom first, then to the side edges of the quilt top; press the seam allowances toward the outer border.

7. Remove the foundation paper.

FINISHING THE QUILT

1. Following the quilt diagram on page 14, draw a curved, looping line between each pair of mittens. Use a chalk marker, chalk pencil, or washout pen so you can remove the lines after quilting.

2. Baste together the quilt top, batting, and backing.

3. Quilt the looping lines. If desired, match your quilting thread to each pair of mittens.

4. Quilt in-the-ditch along the inside edge of the outer border.

5. Bind the edges of the quilt with ½"-wide binding.

6. Sew buttons to the cuffs of the mittens in matching pairs.

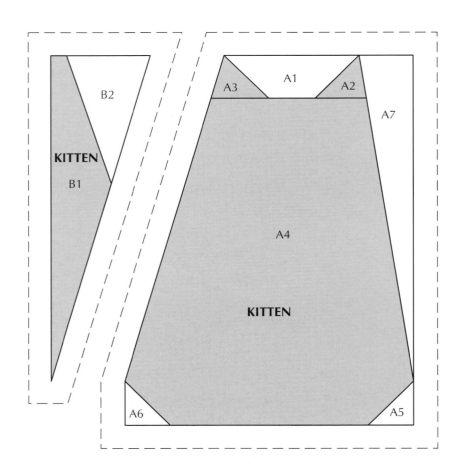

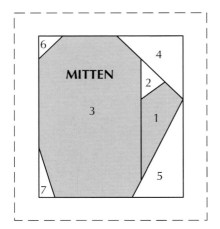

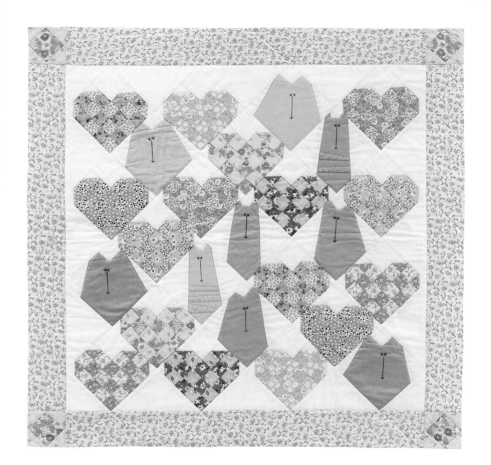

My Funny Valentine
by Julie Hine, 1998,
Lynnwood, Washington,
34¼" x 34¼".
Checkered hearts alternate
with goofy cats in Aunt
Gracie reproduction fabrics.

Funny Friends
by Janet Kime, 1997,
Vashon Island, Washington,
39" x 34". Fat, skinny,
and in between, these cats
are the product of an
extensive fabric collection!

Meow Mix
by Lois Shevlin, 1998,
Princeton Junction, New Jersey,
21½" x 23½".
Black cats and white cats
alternate in this easy-to-piece
design.

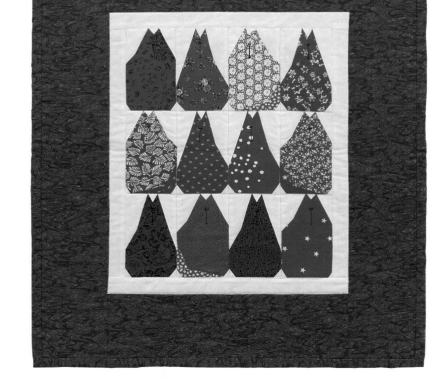

The Cats in Red Square
by Janet Kime, 1998,
Vashon Island, Washington,
21½" x 24".
These aren't Moscow cats;
there is a Red Square at the
University of Washington and
a colony of cats.

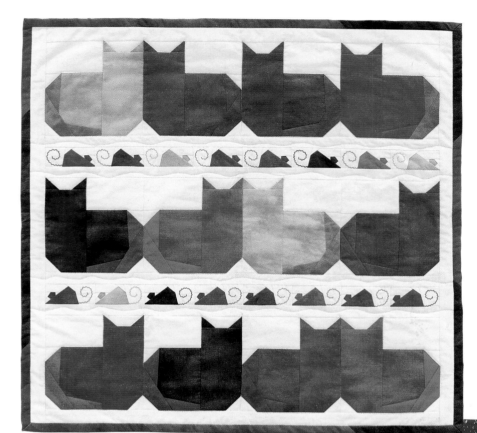

Charles's Quilt
by Janet Kime, 1998,
Vashon Island, Washington,
27" x 26½".
All the tails are curled in
this quilt, made from a
packet of fat quarters.
For Charles's story,
see the song lyrics on
page 39.

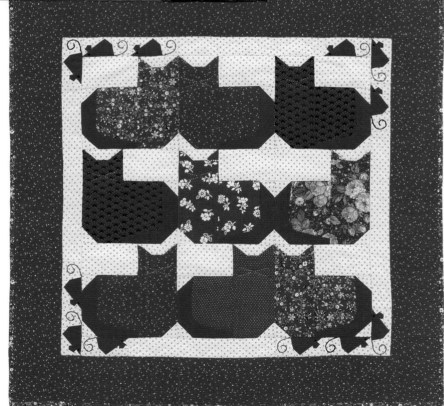

We're Surrounded
by Jo Kautz, 1998,
Austin, Texas, 26½" x 26½".
Saucy mice scamper around a
group of nine red cats.

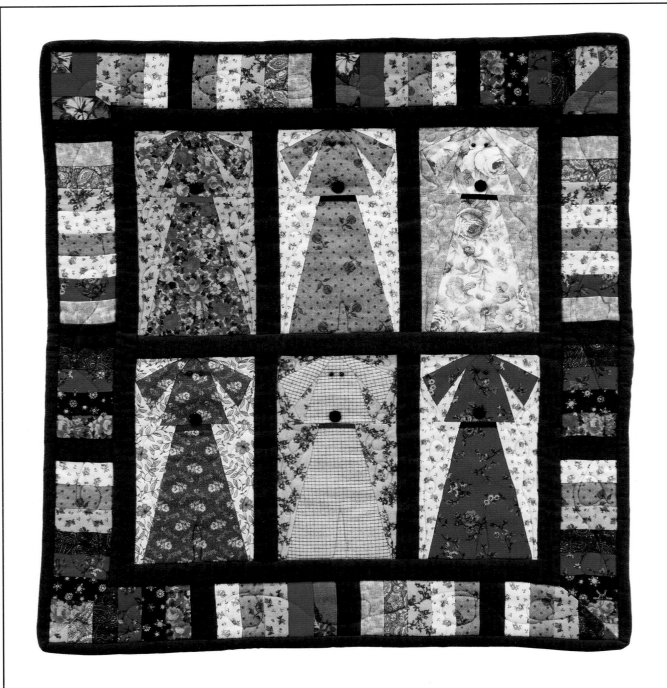

My Funny Flannel Friends
by Karen Gabriel, 1998,
Princeton Junction, New Jersey,
24½" x 26".
These lovable flannel dogs have
button noses and a simple
speed-pieced border.

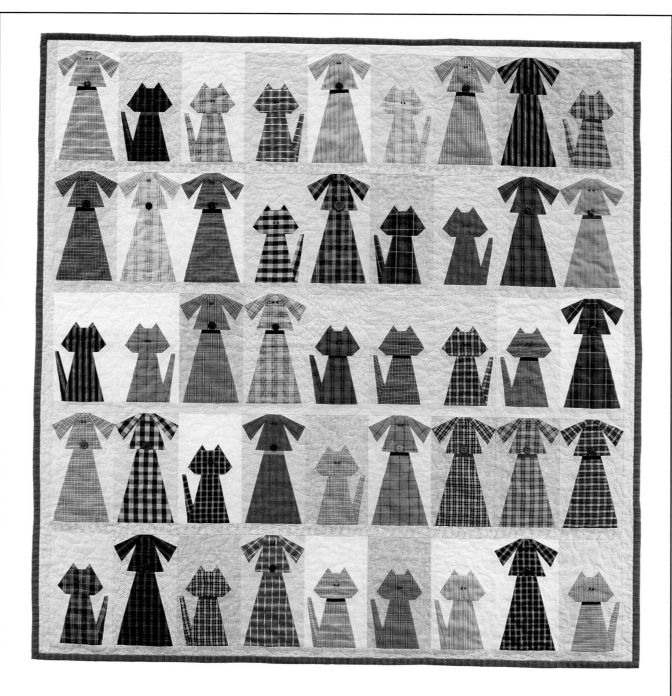

Mutts and Friends
by Janet Kime, 1998,
Vashon Island, Washington, 48" x 52".
Each plaid dog has a plaid cat pal, so
this lap quilt is a matching game. One
cat is hiding on the back.

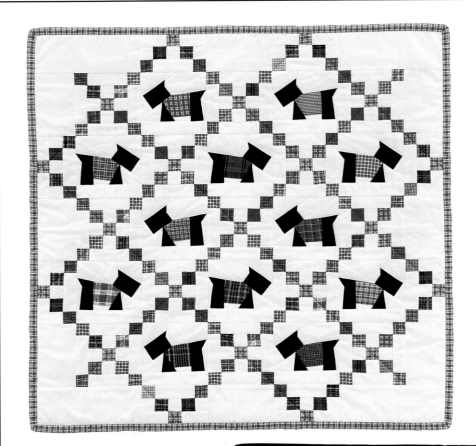

Angus in Plaids
by Virginia Morrison, 1998,
Seattle, Washington, 32" x 32".
Lots of Scotty dogs are
scampering around in
plaid jackets.

"Angus, Come!"
by Karen Gabriel, 1997,
Princeton Junction, New Jersey,
20" x 20".
Sometimes Angus comes
when you call,
and sometimes . . .

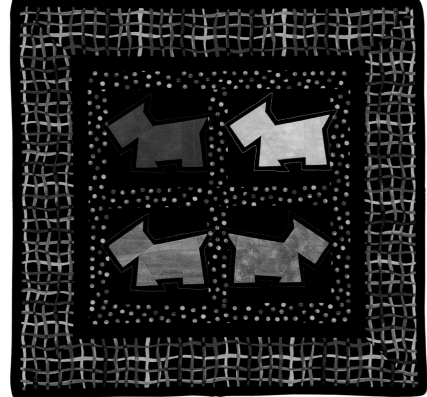

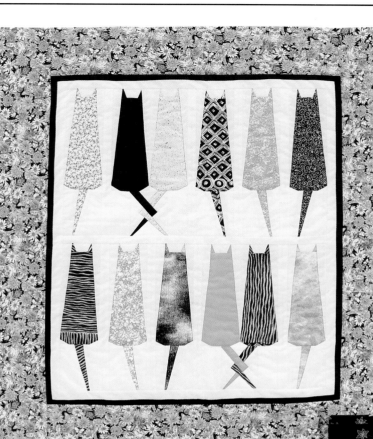

Lucifer and Friends
by Marian Johnson, 1998,
Bellaire, Michigan, 31½" x 35¼".
Lucifer is a black cat who was
born on Friday the thirteenth in
Hell, Michigan! He and his
friends Artie and Hobbs are
featured in this quilt.

Tryst
by Janet Kime, 1998,
Vashon Island, Washington, 17" x 25".
Together, alone in a garden, under the moon and
stars—what could be more romantic?

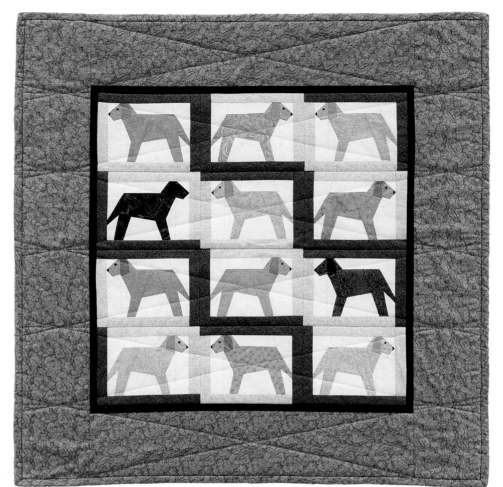

Fetching
by Virginia Morrison,
1998, Seattle,
Washington, 34½" x 36".
A black Lab and a
chocolate Lab have
joined these golden
retrievers.

In the Doghouse
by Janet Kime, 1998,
Vashon Island,
Washington,
31½" x 22".
These fantasy
doghouses were inspired
by the paintings of Sherri
Buck Baldwin.

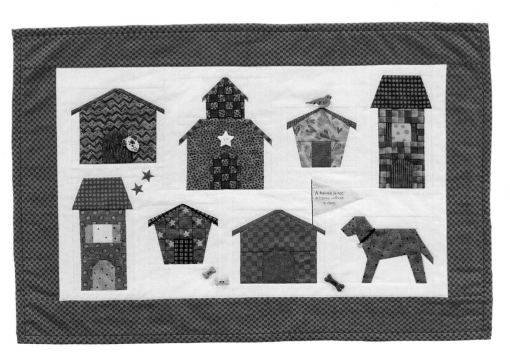

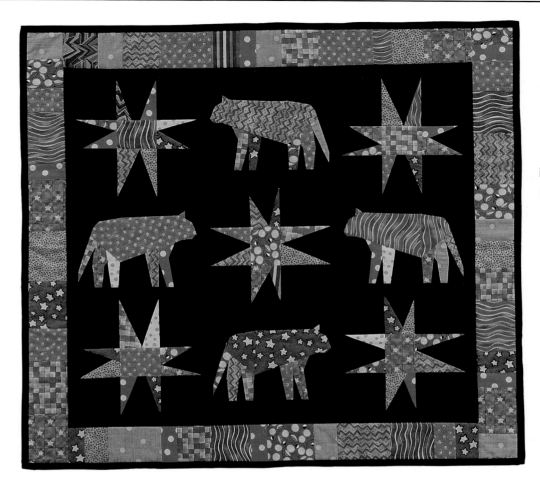

WildCats
by Janet Kime,
1998,
Vashon Island,
Washington,
38" x 35".
Wild fabrics and
irregular stars make
this a cat quilt with
a difference.

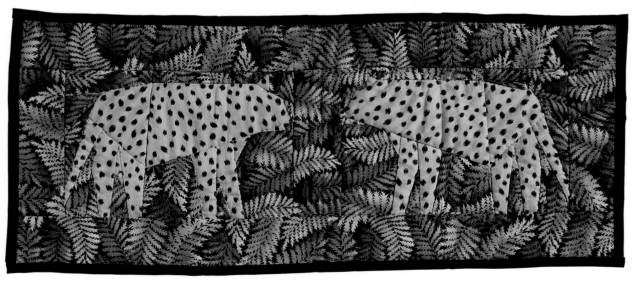

Jumping Jaguars—There Are Two of Us!
by Carolyn Bohot, 1998, Austin, Texas, 22½" x 10".
Two spotted cats discover each other in a jungle of ferns.

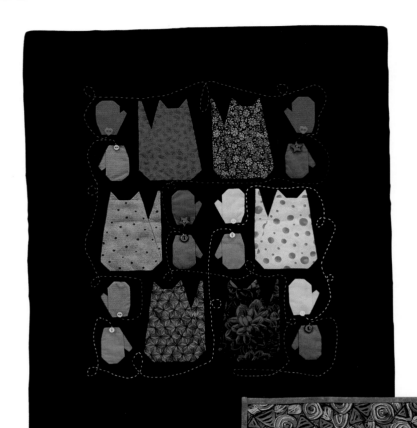

Kittens and Mittens
by Virginia Morrison,
1998, Seattle, Washington, 17" x 20".
These kittens have lost their mittens,
but they haven't gone far.

Travis's Quilt
by Carolyn Bohot, 1998,
Austin, Texas, 21½" x 24½".
Travis was a much beloved orange
cat, remembered here times nine.

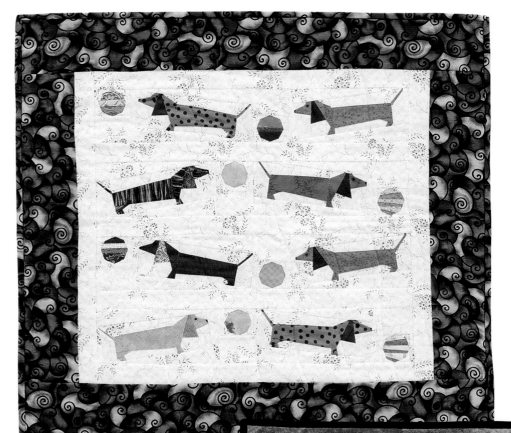

Chasing the Ball
by Jolene Otter, 1998,
Edmonds, Washington,
26" x 24".
Back and forth,
up and down,
these energetic
dachshunds chase
bright-colored balls.

Sit Up and Beg
by Jo Kautz, 1998, Austin, Texas,
12½" x 13¼". It's not hard to capture
a dachshund's attention.

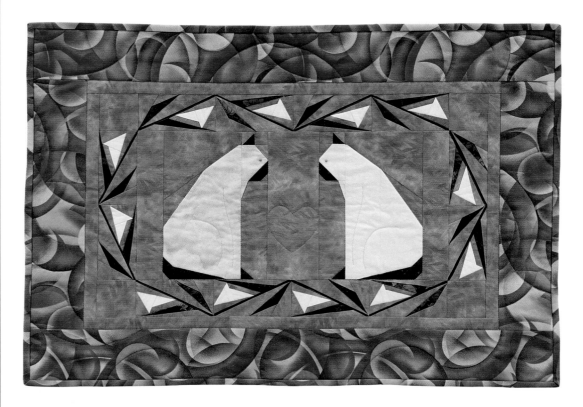

Linus and Samantha
by Karen Gabriel, 1998,
Princeton Junction,
New Jersey, 31" x 22".
These two pals are
surrounded by a vine of
morning glories.
Owned by Susi and
Bill Traver.

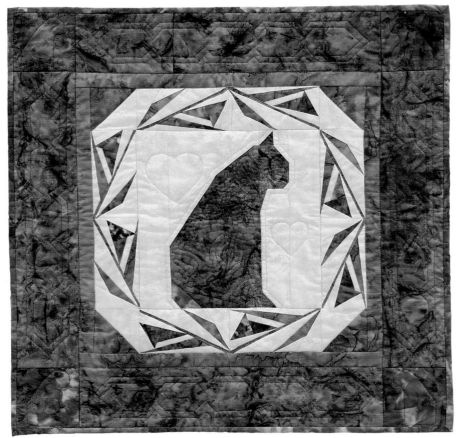

Sophis-T-Cat
by Lorraine Herge, 1998,
Concord, North Carolina,
21" x 21". Beautiful
variegated fabrics
complement this
graceful design.

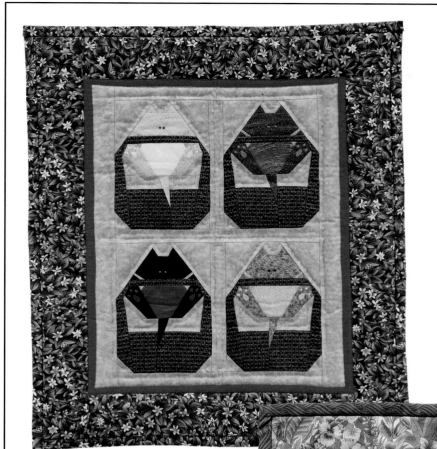

Hanging BasKats
by Nancy Noerpel, 1998,
Lovettsville, Virginia, 24" x 28".
Each of these chubby kittens is trying
valiantly to scramble up the handle of
the basket. Owned by Diane Noerpel.

Mickie in the Flower Basket
by Janet Kime, 1998,
Vashon Island, Washington, 14½" x 17".
Mickie gets into everything and,
like all cats, he knows that baskets are
for cats and not flowers.

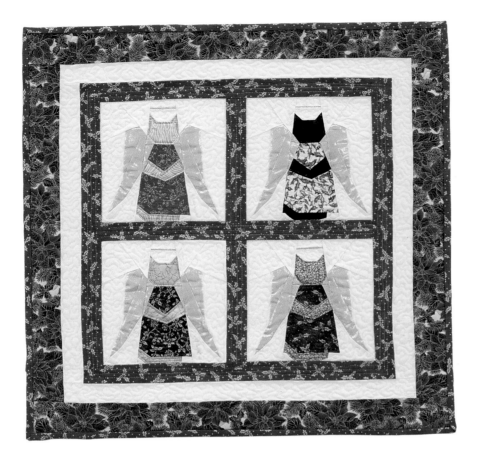

**Angels Who
Meow on High**
by Sue Bower, 1998,
Hamilton Square, New Jersey,
21" x 21". These Christmas
angels glitter with gold.
Owned by Elaine Rymsza.

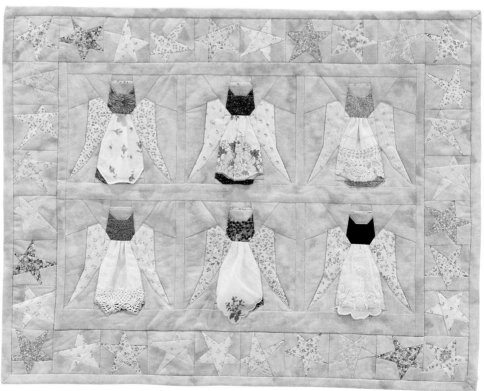

Little Angels
by Janet Kime, 1998,
Vashon Island,
Washington, 26" x 21".
Tiny flower prints and
old linens make this a
delicate Christmas quilt.

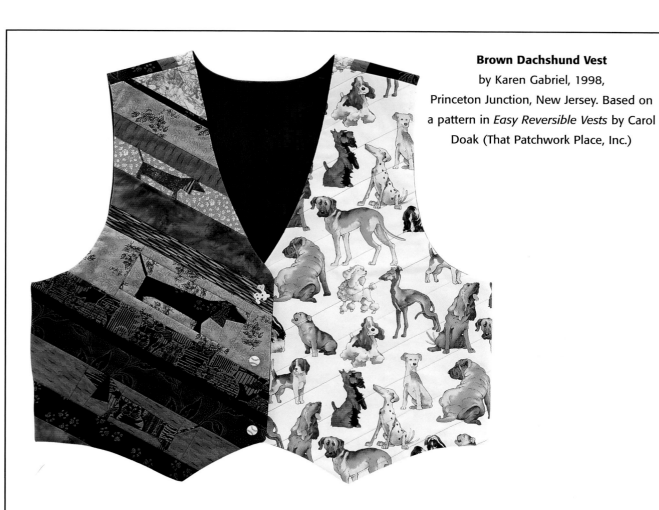

Brown Dachshund Vest
by Karen Gabriel, 1998,
Princeton Junction, New Jersey. Based on
a pattern in *Easy Reversible Vests* by Carol
Doak (That Patchwork Place, Inc.)

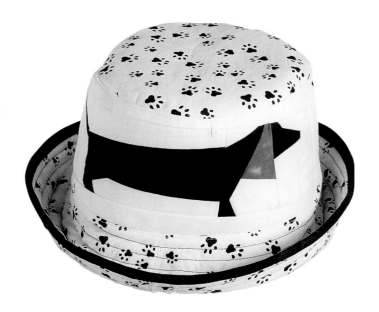

Black and White Dachshund Hat
by Karen Gabriel, 1998, Princeton Junction,
New Jersey. Based on a pattern in *Funky
Fabric Hats* by Suzy Lawson (American
School of Needlework, Inc.)

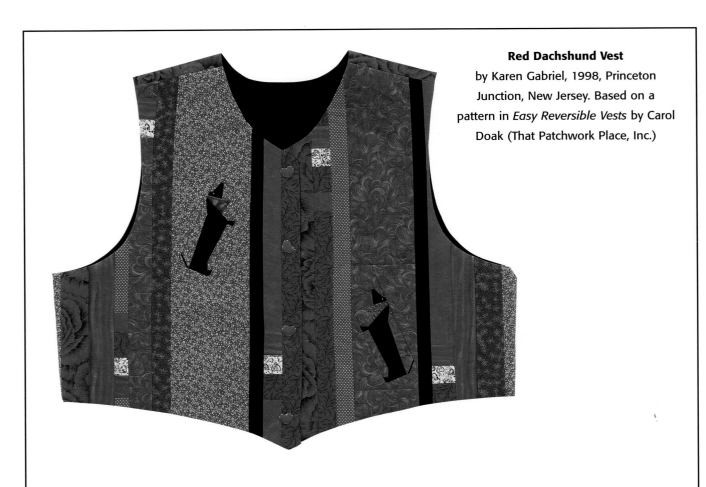

Red Dachshund Vest
by Karen Gabriel, 1998, Princeton Junction, New Jersey. Based on a pattern in *Easy Reversible Vests* by Carol Doak (That Patchwork Place, Inc.)

Red Dachshund Hat
by Karen Gabriel, 1998, Princeton Junction, New Jersey. Based on a pattern in *Funky Fabric Hats* by Suzy Lawson (American School of Needlework, Inc.)

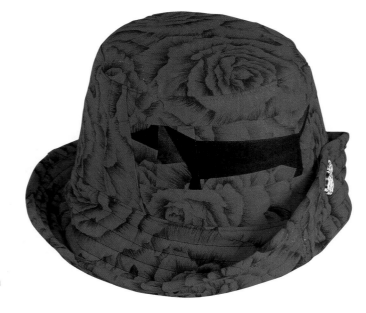

Meow Mix

Many of our feline friends are, well, a little pear-shaped. These pointy-eared, broad-in-the-hips cats are easy to piece. You can frame the blocks as described here, or make the blocks without the frames as in "The Cats in Red Square" (page 18).

Color Photo: page 18
Quilt Size: 21½" x 23½"
Finished Block Size: 4" x 6"

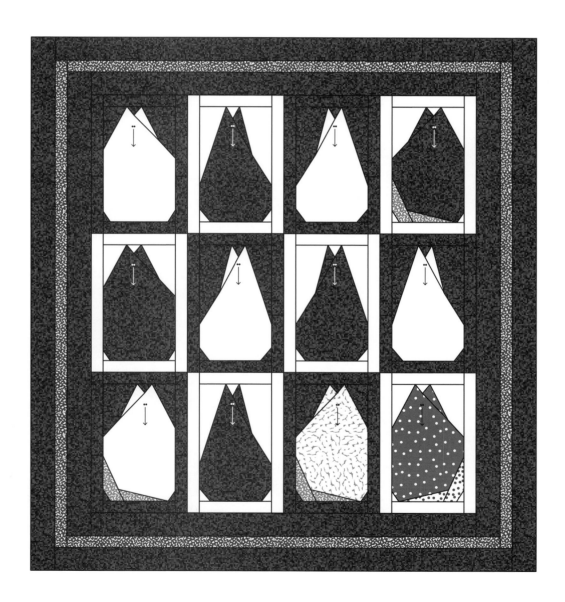

Fabric	Piece	No. of Pieces	Dimensions
Light	Top and bottom framing strips	12	1¼" x 4"
	Side framing strips	12	1¼" x 7"
Dark	Top and bottom framing strips	12	1¼" x 4"
	Side framing strips	12	1¼" x 7"
	Top and bottom inner border	2	1½" x 16½"
	Side inner border	2	1½" x 20½"
	Top and bottom outer border	2	1½" x 19½"
	Side outer border	2	1½" x 23½"
Accent	Top and bottom accent strips	2	1" x 18½"
	Side accent strips	2	1" x 21½"

MATERIALS: *42"-wide fabric*

1 yd. total dark fabrics for cats, framing strips, borders, and binding

½ yd. total light fabrics for cats and framing strips

¼ yd. for accent strips

¾ yd. for backing

Fine-line permanent pen, embroidery floss, seed beads, and/or fabric paint for faces

CUTTING

N O T E : Referring to the chart above, cut the framing and border strips from the fabric first, then use the remaining fabric to foundation-piece the blocks. Measurements are given to precut the framing strips around each block. These measurements are generous, leaving some excess to cut away when you trim the blocks before setting them together.

PIECING THE BLOCKS

Refer to "Foundation Piecing" on pages 5–8. Use the patterns on page 36.

Foundation-piece 6 of each cat, reversing some for added interest; make 12 cats total. Make 6 dark cats with light backgrounds, and 6 light cats with dark backgrounds. If you wish, omit the tail on some cats.

ASSEMBLING THE QUILT TOP

1. Arrange the blocks in 3 rows of 4 each, alternating dark and light cats.

2. Sew the blocks in each row together, pressing the seam allowances toward the dark backgrounds.

3. Sew the rows together and press. Remove the foundation paper.

4. Sew the inner border strips to the top and bottom first, then to the side edges of the quilt top; press the seam allowances toward the inner border.

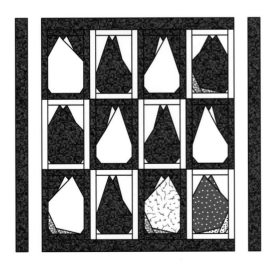

5. Sew the accent strips to the top and bottom first, then to the side edges of the quilt top; press the seam allowances toward the accent fabric.

6. Sew the outer border strips to the top and bottom first, then to the side edges of the quilt top; press the seam allowances toward the accent fabric.

FINISHING THE QUILT

1. Baste together the quilt top, batting, and backing.

2. Quilt around each cat and in-the-ditch between the blocks. Quilt in-the-ditch on both sides of the accent strip.

3. Bind the edges of the quilt with ¼"-wide binding.

4. Draw on the faces. Embroider, paint, or sew on seed beads for the eyes (see "Adding Faces and Other Details" on page 13).

CREATE-A-CAT

Try moving the piecing lines on these cats to change their personalities.

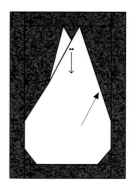 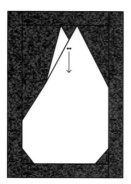

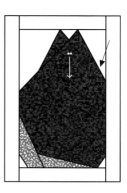 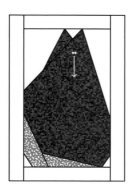

Optional: The tail pieces 6 and 7 can be omitted; make piece 4 larger to cover the area previously covered by 6 and 7.

Charles's Quilt

This cat-and-mouse quilt is easy to piece and a good project for beginners, especially if you have never used a foundation pattern with sections. There are no points to match when the sections are sewn together.

Color Photo: page 19
Quilt Size: 27" x 26½"
Finished Block Sizes
 Cat: 6" x 6"
 Mouse: 1¼" x 3"

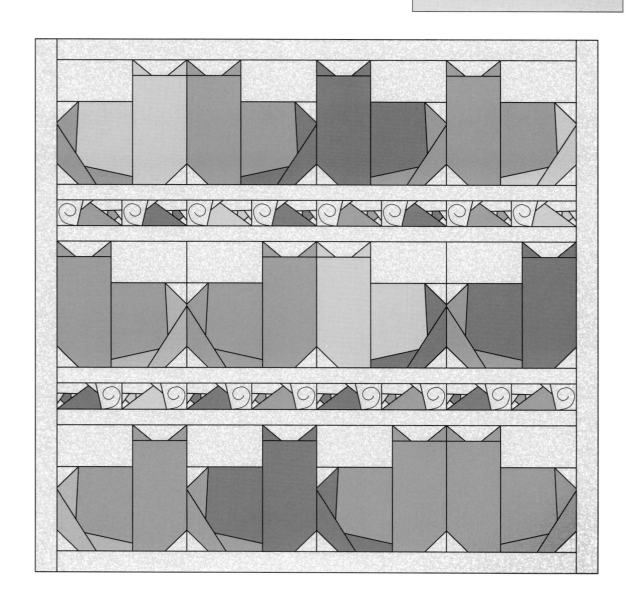

Fabric	Piece	No. of Pieces	Dimensions
Background	Horizontal sashing	4	1¼" x 24½"
	Top and bottom border	2	1½" x 24½"
	Side border	2	1½" x 26"

MATERIALS: *42"-wide fabric*

1⅛ yds. total for cats, mice, and binding

1 yd. for background

1 yd. for backing

CUTTING

NOTE: Referring to the chart above, cut the sashing and border strips from the background fabric first, then use the remaining fabric to foundation-piece the blocks.

PIECING THE BLOCKS

Refer to "Foundation Piecing" on pages 5–8. Use the patterns on page 40.

1. Foundation-piece 12 cats, 6 plus 6 reversed.

2. Foundation-piece 16 mice, 8 plus 8 reversed.

ASSEMBLING THE QUILT TOP

1. Arrange the cats in 3 rows of 4 cats each. Sew the cats in each row together. Press, then remove the foundation paper from the seam allowances of the sewn seams.

2. Staystitch around each row, ⅛" from the outer edges. Remove the foundation paper.

3. Arrange the mice in 2 rows of 8 mice each. Sew the mice in each row together. Press, then remove the foundation paper from the seam allowances of the sewn seams.

4. Sew the sashing strips to the top and bottom of each row of mice. Press the seam allowances toward the sashing strips. Remove the foundation paper.

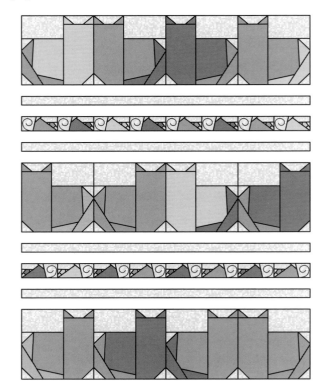

5. Embroider the mouse tails, using a simple stem stitch or chain stitch (see "Adding Faces and Other Details" on page 13 or the "Tip" on page 39 for a decorative stitch).

6. Sew the rows of the quilt together.

7. Sew the border strips to the top and bottom first, then to the side edges of the quilt top; press the seam allowances toward the border.

FINISHING THE QUILT

1. Baste together the quilt top, batting, and backing.

2. Quilt around each cat. Quilt a wavy line in each of the horizontal sashing strips, above and below each row of mice.

3. Bind the edges of the quilt with ½"-wide binding. The binding of "Charles's Quilt" was made from 10"- to 12"-long strips of several fabrics.

Tip

This easy decorative stitch looks like tiny rickrack and contributes to the whimsy of the quilt. By starting and stopping the stitching where the tail emerges from the mouse body, you can hide your knot and fastening-off stitches in the mouse seam allowances.

Starting at the mouse body, embroider the tail in a simple running stitch. At the tip of the tail, start back in the other direction, weaving the needle and thread through the stitches on the top of the quilt.

CHARLES THE CAT

There was one spring a tulip patch,
All red and gold, a fearsome sight;
A dreaded tulip patch it was,
A danger and a blight.

All hail to Charles the Siamese,
With bashed-in ear and broken tooth,
Who rolls among the radishes
And dances on the roof.

Charles circled slow that tulip patch,
On guard for sneak attack.
He isolated one, blood-red,
And crept up to its back;

With one brave leap he felled it,
And nipped it in the bud,
And brought his trophy home to me;
And killed it on the rug.

All hail to Charles the mighty,
With broken tooth and bashed-in ear,
Who digs up the nasturtiums
And shows no sign of fear.

So, one by one those tulips fell;
And one by one they came
To lie in death throes on my floor
While Charles went dancing out the door
To conquer another and then one more
Until there were left only empty stems;
And I hope to goodness they'll grow again,
I even planted more.

So hail to Charles the fearless,
Protector of the house;
The foe of all things planted,
The friend of every mouse.

—ELIZABETH ANTHONY, 1984
for the vocal group Women, Women, and Song

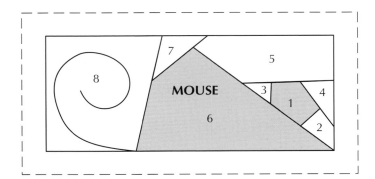

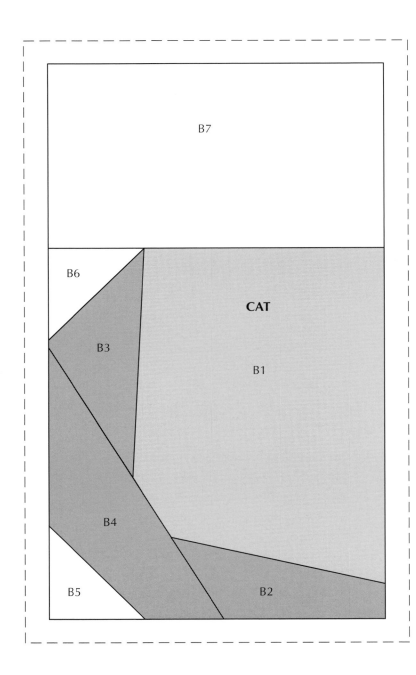

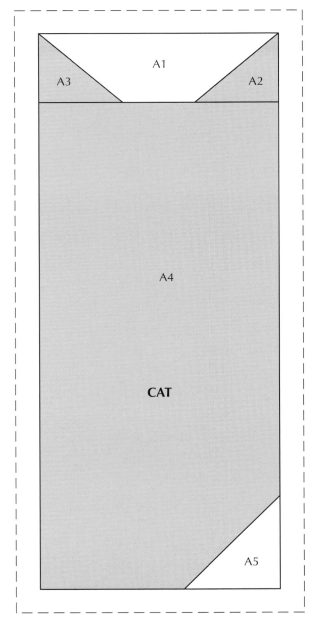

Mutts and Friends

These cats and dogs may not be purebred, but they have a lot of charm. Unlike most foundation-pieced designs, they are easy to sew in directional prints and plaids.

Color Photo: page 21
Quilt Size: 48" x 52"
Finished Block Size: 5" x 9"

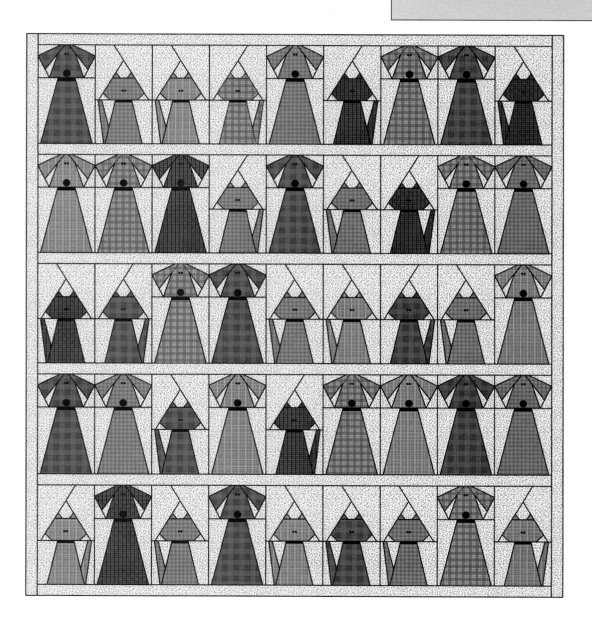

Fabric	Piece	No. of Pieces	Dimensions
Background	Horizontal sashing	4	1½" x 45½"
	Top and bottom border	2	1½" x 45½"
	Side border	2	1½" x 51½"

MATERIALS: *42"-wide fabric*

2¾ yds. total for dogs, cats, and binding

Scraps for collars

3 yds. for background, sashing, and border

3 yds. for backing

Embroidery floss; 90 beads, 3mm in diameter; or fabric paint for eyes

23 buttons, ⅜" to ½" in diameter

CUTTING

NOTE: Referring to the chart above, cut the sashing and border strips from the background fabric first, then use the remaining fabric to foundation-piece the blocks.

PIECING THE BLOCKS

Refer to "Foundation Piecing" on pages 5–8. Use the patterns on pages 43–45. If you are using plaids or directional prints, use the center lines on the foundation patterns to line up the fabric. You can omit the collars and/or the cat tails on some or all the blocks if you wish.

NOTE: If you want to make your quilt a matching game, like the sample quilt "Mutts and Friends," make 23 cats that match the 23 dogs, and appliqué the extra cat to the back of the quilt.

1. Foundation-piece 23 dogs.

2. Foundation-piece 22 cats, reversing sections B and C on some of the blocks.

ASSEMBLING THE QUILT TOP

1. Arrange the Cat and Dog blocks in 5 rows. Sew the blocks in each row together. Press the seam allowances, then staystitch around each row, ⅛" from outer edges. Remove the foundation paper.

2. Sew the rows together with a sashing strip between each pair of rows. Press the seam allowances toward the sashing strips.

3. Sew the border strips to the top and bottom first, then to the side edges of the quilt top; press the seam allowances toward the border.

FINISHING THE QUILT

1. Baste together the quilt top, batting, and backing.

2. Quilt random loops in the background fabric between the cats and dogs.

3. Bind the edges of the quilt with ½"-wide binding.

4. Embroider, paint, or sew on beads for the eyes (see "Adding Faces and Other Details" on page 13).

5. Sew on the buttons for the dog noses, sewing through all layers.

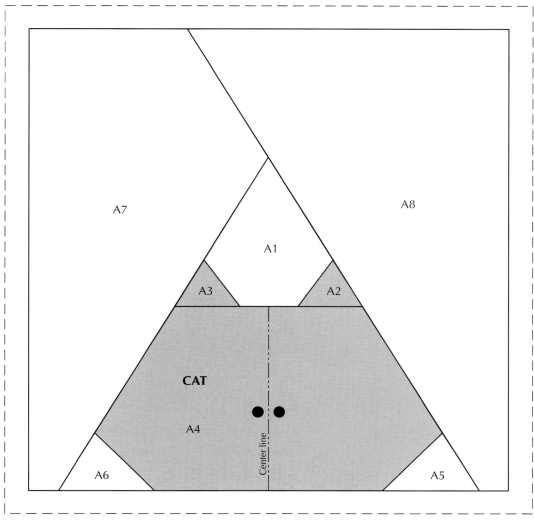

A7

A8

A1

A3 A2

CAT

A4

Center line

A6 A5

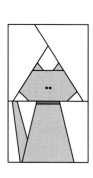

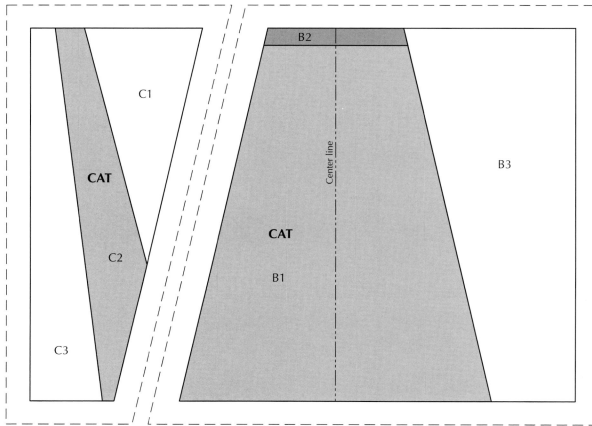

C1

CAT

C2

C3

B2

B3

Center line

CAT

CAT

B1

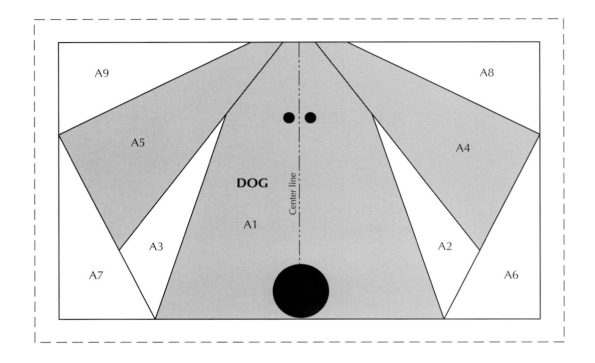

A9

A8

A5

A4

DOG

Center line

A1

A3

A2

A7

A6

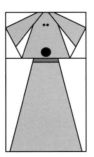

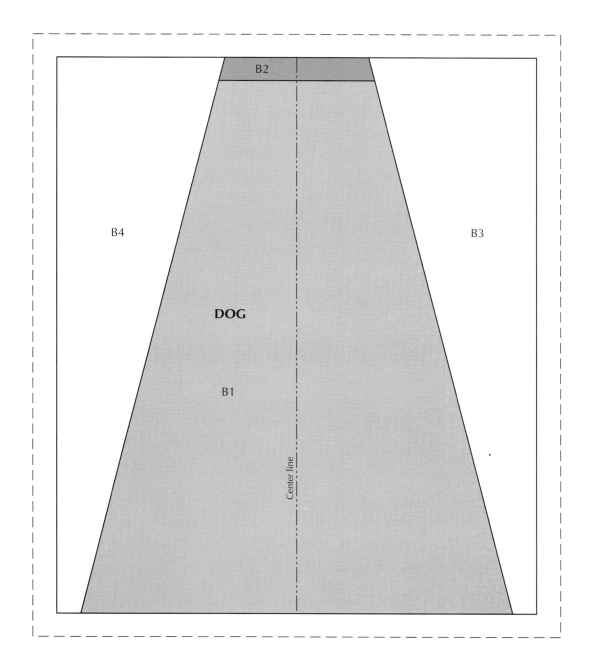

B2

B4

B3

DOG

B1

Center line

My Funny Valentine

foundation-pieced goofy cats alternate with speed-pieced, checkered hearts in this quilt. Select the fabrics for the checkered hearts carefully; the two fabrics in each pair should be fairly similar, and both should contrast well with the background fabric.

Color Photo: page 17
Quilt Size: 34¼" x 34¼"
Finished Block Size: 5" x 5"

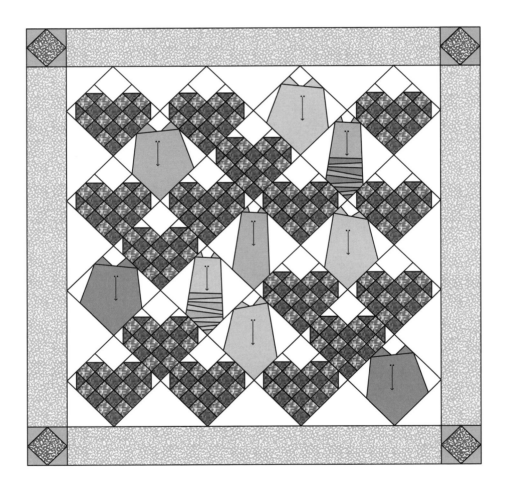

Fabric	Piece	No. of Pieces	Dimensions
Heart	Fabric A	16	1½" x 22"
	Fabric B	16	1½" x 22"
Background	Heart	64	1½" x 1½"
	Heart	16	2½" x 2½"
	Side triangles	3	8½" x 8½" *
	Corner triangles	2	4½" x 4½" **
Border	Border strips	4	3¼" x 28¾"

*Cut each square twice diagonally to make 4 triangles (12 triangles total).

**Cut each square once diagonally to make 2 triangles (4 triangles total).

MATERIALS: *42"-wide fabric*

- 1¼ yds. total prints for hearts, cats, and corner squares
- 1 yd. for background and binding
- ½ yd. for border
- 1¼ yds. for backing
- Embroidery floss, fabric paint, or fine-line permanent pen
- 18 beads, 3mm in diameter

CUTTING

NOTE: Referring to the chart above, cut the heart pieces, the side and corner triangles, and the binding strips from the background fabric first, then use the remaining fabric to foundation-piece the Cat blocks.

PIECING THE BLOCKS

Press all seam allowances in the direction of the arrows unless otherwise instructed.

Heart Blocks

Refer to "Speed Piecing" on page 9. Each heart is made from 1 strip of fabric A and 1 strip of fabric B, with each strip measuring 1½" x 22". Make 16 hearts.

1. Sew a strip A to a strip B to make an A/B unit.

2. Crosscut the A/B unit into 3 pieces, each 7" wide.

3. Sew the 3 crosscuts together to make 1 unit, alternating the colors. Press the seam allowances toward the darker fabric.

4. Even up one edge of the unit with a clean-up cut, then make 4 crosscuts, each 1½" wide.

5. Lay out the 4 crosscuts as shown below. The first crosscut on the left should have the dark fabric at the top and the light fabric at the bottom.

6. Modify the crosscuts as shown. From the first 3, rip out a seam and remove an end square. Discard these squares. Rip out the center seam in the fourth crosscut and save both pieces. Press all the pieces.

7. With a ruler, draw a faint diagonal line on the wrong side of each of the 64 small background squares.

8. Speed-piece a 1½" background square to the first crosscut as shown. Trim away the corner.

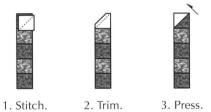

1. Stitch. 2. Trim. 3. Press.

9. Speed-piece background squares to the top of the third crosscut and to the top and bottom of the fourth crosscut piece with dark squares at the top and bottom.

10. Sew the first 3 crosscuts together.

11. Sew the 2 pieces of the fourth crosscut together. Press the seam allowances away from the speed-pieced corners. Sew this unit to the 2½" background square. Press the seam allowances toward the background square.

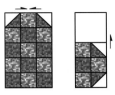

12. Sew the 2 units together to make the heart.

Cat Blocks
Refer to "Foundation Piecing" on pages 5–8. Use the patterns on pages 50–52.

1. Foundation-piece 9 cats from the 3 patterns, reversing some of the cats.

2. Trace the lines for the cat faces, then draw the faces with a permanent pen, paint with fabric paint, or embroider them (see "Adding Faces and Other Details" on page 13). Notice in the color photograph of "My Funny Valentine" (page 17) that some of the faces are not straight up and down, but are tilted to one side or the other. This little touch makes the quilt delightfully whimsical; the cats look like they are peering around corners.

ASSEMBLING THE QUILT TOP

1. Arrange the Heart and Cat blocks, following the diagram of the quilt. Add background triangles to the ends of the rows as shown.

2. Sew the blocks together in diagonal rows. (The side triangles are slightly large and will be trimmed in step 5.) Press the seam allowances of each row in one direction. Press seam allowances from row to row in opposite directions.

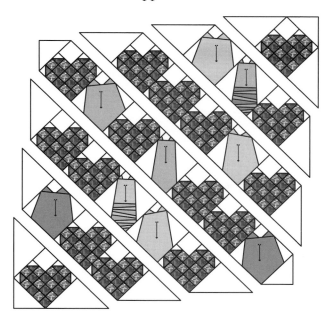

3. Staystitch around each row, ⅛" from the outer edges. Remove the foundation paper.

4. Sew the rows together. Press the seam allowances in either direction.

5. Trim the outer edges of the quilt, leaving ¼"-wide seam allowances all around.

6. Using the pattern on page 52, foundation-piece 4 corner squares. Sew them to the ends of 2 of the border strips.

7. Sew the 2 border strips without corner squares to the sides first, then sew the border strips with corner squares to the top and bottom of the quilt top. Press the seam allowances toward the border.

FINISHING THE QUILT

1. Baste together the quilt top, batting, and backing.

2. Machine quilt along each diagonal line and around each cat.

3. Bind the edges of the quilt with ¼"-wide binding.

4. Sew bead eyes to each cat, sewing through all layers.

CREATE-A-CAT

- The three cats in this quilt are all variations on one basic cat. Individualize your cats by making slight alterations in the foundation-piecing patterns; move the lines to make the cats fatter or thinner, more symmetrical or more lopsided, or with bigger or smaller ears.

- The cats can also be individualized by strip piecing the bodies to make a striped cat. In place of piece 4, alternate strips of the cat fabric and a coordinating fabric, cutting the strips in random widths and sewing them on at varying angles.

Angus in Plaids

This quilt alternates speed-pieced Country Lane blocks with foundation-pieced Scotty Dog blocks.

Color Photo: page 22
Quilt Size: 32" x 32"
Finished Block Size: 5" x 5"

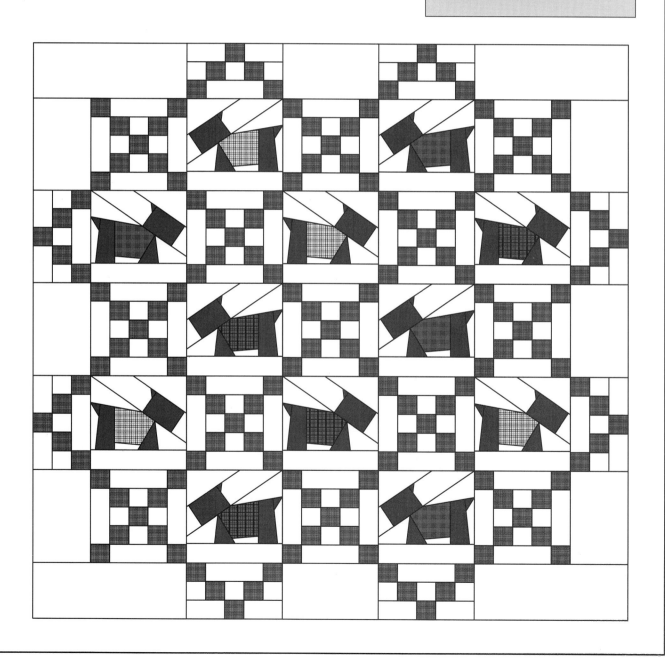

Fabric	No. of Pieces	Dimensions
Background	8	3½" x 5½"
	4	3½" x 8½"
	26	1½" x 3½"

MATERIALS: *42"-wide fabric*

> ½ yd. black fabric for Scotty dogs
>
> ¾ yd. total red plaids for jackets, Country Lane blocks, and binding
>
> 1½ yds. for background
>
> 1¼ yds. for backing

CUTTING

NOTE: Referring to the chart above, cut the strips for the Country Lane blocks and the rectangles listed from the background fabric first, then use the remaining fabric to foundation-piece the Scotty Dog blocks.

PIECING THE BLOCKS

Press all seam allowances in the direction of the arrows unless otherwise instructed. Refer to "Speed Piecing" on page 9.

Country Lane Blocks

If you are making the blocks from several different plaids, make enough short strip units to provide the total number of crosscuts needed to make 13 Country Lane blocks.

1. Sew strip units A, B, and C, referring to the illustration; cut the strips in the widths indicated. Even up one edge of each unit with a clean-up cut and make the following crosscuts, each 1½" wide:

 A 26 crosscuts (about 42" total)

 B 13 crosscuts (about 23" total)

 C 26 crosscuts (about 42" total)

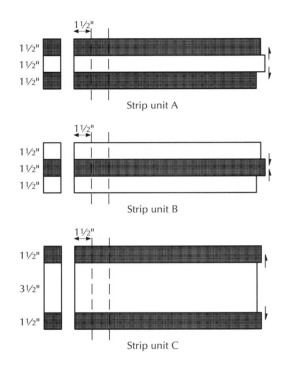

2. Sew together 2 of crosscut A and 1 of crosscut B as shown.

3. Sew 1½" x 3½" background strips to 2 sides of the nine-patch unit.

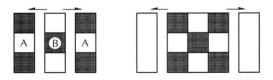

4. Sew C crosscuts to the top and bottom of the nine-patch unit.

Partial Country Lane Blocks

If you are making the blocks from several different plaids, make enough short strip units to provide the total number of crosscuts needed for 8 partial blocks (about 14" of each strip unit C, D, and E).

1. Make strip unit C, referring to the illustration; press the seam allowances toward the plaid fabric.

2. Make strip units D and E, referring to the illustration, and press as shown.

3. Even up one edge of each unit with a clean-up cut and make 8 crosscuts, each 1½" wide (about 14" total of each strip unit C, D, and E).

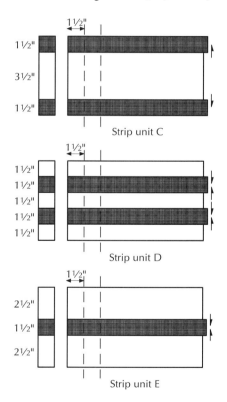

4. Sew together 1 crosscut each of C, D, and E to make each partial block.

Scotty Dog Blocks

Refer to "Foundation Piecing" on pages 5–8. Use the patterns on page 56.

Foundation-piece 12 Scotty Dog blocks. Sew section A to section B; then add the remaining sections in alphabetical order.

ASSEMBLING THE QUILT TOP

1. Following the quilt diagram, arrange the Scotty Dog, Country Lane, and partial Country Lane blocks. Sew background rectangles to the ends of the rows as shown.

2. Sew the blocks together in rows; press the seam allowances away from the Scotty Dog blocks.

3. Sew the rows together and press. Remove the foundation paper.

FINISHING THE QUILT

1. Baste together the quilt top, batting, and backing.

2. Machine quilt along each diagonal line of plaid squares and around each Scotty Dog.

3. Bind the edges of the quilt with ½"-wide binding.

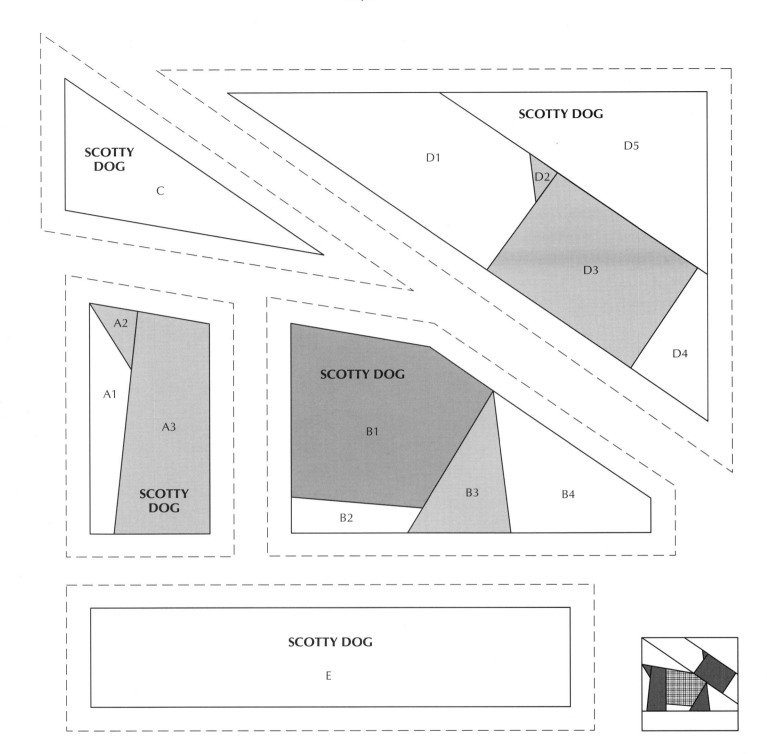

SCOTTY DOG

D5

D1

D2

C

SCOTTY
DOG

D3

D4

A2

A1

A3

SCOTTY
DOG

SCOTTY DOG

B1

B3

B4

B2

SCOTTY DOG

E

Lucifer and Friends

Some of these cats are just friends, and some have a closer relationship. For the affectionate pairs of cats, select two fabrics with enough contrast so the entwined tails can be seen.

> **Color Photo: page 23**
> **Quilt size: 31½" x 35¼"**
> **Finished Block Sizes**
> **Single Cat: 3" x 12"**
> **Entwined-Tail Pair of**
> **Cats: 6" x 12"**

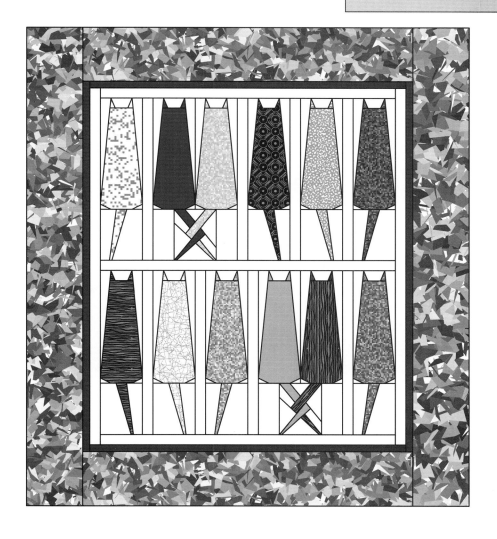

CUTTING

Fabric	Piece	No. of Pieces	Dimensions
Background	Sides of entwined tails	4	2" x 4¼"
	Vertical sashing	8	1¼" x 12½"
	Horizontal sashing	1	1¼" x 21½"
	Top and bottom inner border	2	1¼" x 21½"
	Side inner border	2	1¼" x 26¾"
Accent	Top and bottom	2	1" x 23"
	Sides	2	1" x 27¾"
Outer Border	Top and bottom	2	4½" x 24"
	Sides	2	4½" x 35¾"

MATERIALS: *42"-wide fabric*

⅓ yd. total OR scraps for cats

1 yd. for background and inner border

¼ yd. for accent

1 yd. for outer border and binding

1¼ yds. for backing

PIECING THE BLOCKS

Refer to "Foundation Piecing" on pages 5–8. Use the patterns on pages 60–61. Press all seam allowances in the direction of the arrows unless otherwise instructed.

1. Foundation-piece 8 single cats, 4 plus 4 reversed. Piece body section A, then tail section B. Sew body and tail sections together. Note that only section B needs to be reversed.

2. Foundation-piece 4 of cat body A for the entwined-tail pairs. Don't sew the pairs of cat bodies together yet; wait until after you piece the tail sections to be sure you put each cat on the correct side.

3. Make 2 entwined-tail units. Piece tail section C, then piece section D. Sew sections C and D together to make a C/D unit. Trim the C/D unit to 3½" x 4¼".

4. Add the 2" x 4¼" background pieces to the sides of each C/D unit.

5. Sew the pairs of A bodies together, checking them against the C/D unit to put the cats in the correct position within the pair. Trim and press the seam allowances open. Trim the bottom edge of the unit, leaving a ¼"-wide seam allowance.

6. Sew the C/D unit to the pair of cat bodies A, matching raw edges and taking a ¼" seam. Match the center arrow on the C/D unit to the center seam of the cats, and match the side arrows on the C/D unit to the corresponding arrows on 1 side of each cat body.

ASSEMBLING THE QUILT TOP

1. Arrange the cats in 2 rows. Sew the Cat blocks in each row together with 12½"-long sashing strips between the blocks. Press the seam allowances toward the sashing strips.

2. Staystitch around each row, ⅛" from the outer edges. Remove the foundation paper.

3. Sew a 21½"-long sashing strip between the 2 rows. Press seam allowances toward the sashing.

4. Sew the inner border strips to the top and bottom edges first, then to the side edges of the quilt top; press the seam allowances toward the inner border.

5. Sew the accent strips to the top and bottom first, then to the side edges of the quilt top; press the seam allowances toward the accent strips.

6. Sew the outer border strips to the top and bottom first, then to the side edges of the quilt top; press the seam allowances toward the outer border.

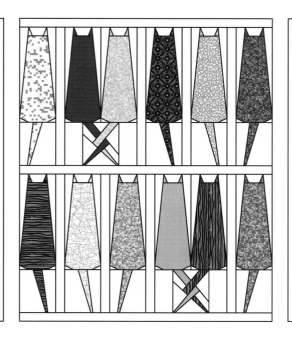

FINISHING THE QUILT

The finishing directions below are for a stitched-and-turned quilt with no binding. If you wish to put binding on the quilt, follow the directions for "Basting the Quilt" on page 11 and "Binding" on page 12.

1. Layer the quilt front and back, right sides together, over the batting; pin.

2. Stitch ¼" from the raw edge of the quilt top, leaving an opening for turning; turn right side out. Slipstitch the opening closed.

3. Baste together the quilt top, batting, and backing.

4. Quilt around each cat and in-the-ditch between the accent strip and the outer border.

Tip

Each entwined-tail pair of cats is 6" wide, and each single cat is 3" wide. If you put sashing strips between the blocks, as in "Lucifer and Friends" (page 23), notice that there is no sashing strip between the entwined-tail cats. Because of this, you need the same number of entwined-tail pairs in each row to make the rows come out the same length. If you like the design better without sashing strips or with only horizontal strips between the rows of cats, you can have any number of entwined-tail pairs in each row.

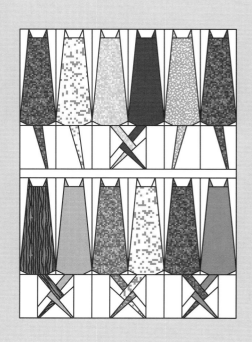

CREATE-A-CAT

∾ This is an easy design to modify. The cat bodies and ears can be short and fat or tall and skinny. The tails can point to the side or straight up and down. You could even create a family portrait with a cat for each member of the family. Use the patterns on this page and page 65 as a guide to create your modified cats.

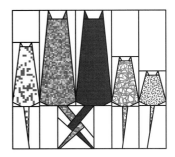

∾ You can also piece the body with random-width strips to make a striped cat.

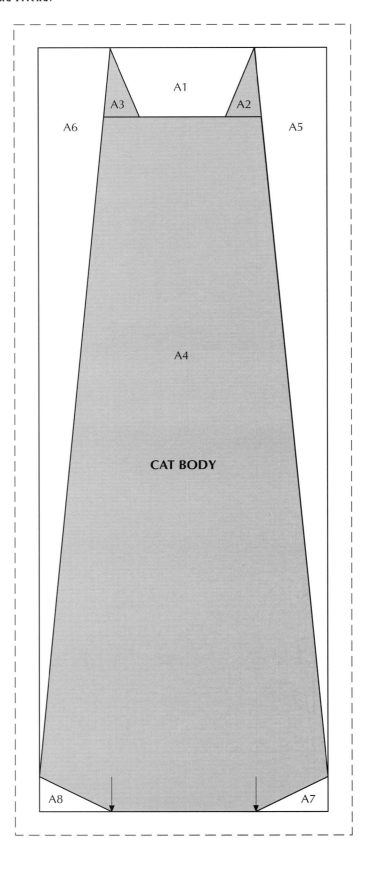

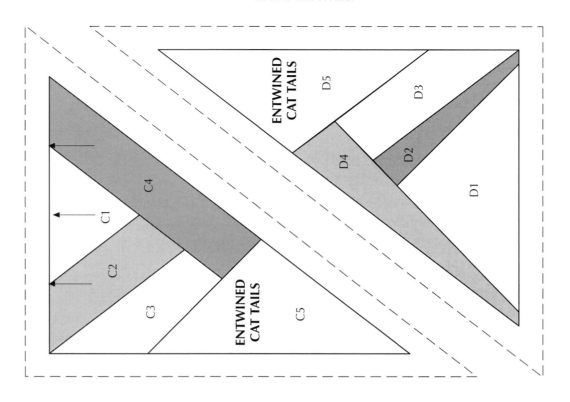

ENTWINED
CAT TAILS

D5

D3

D4

D2

D1

C1

C4

C2

C3

ENTWINED
CAT TAILS

C5

B2

B3

CAT TAIL

B1

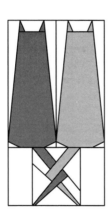

Tryst

feature just one pair of entwined-tail cats in your quilt and commemorate a special romance. Make your quilt with a moon and night sky as in the sample, or use a floral print for the background fabric and set your cats' tryst in a summer garden.

Color Photo: page 23
Quilt Size: 17" x 25"

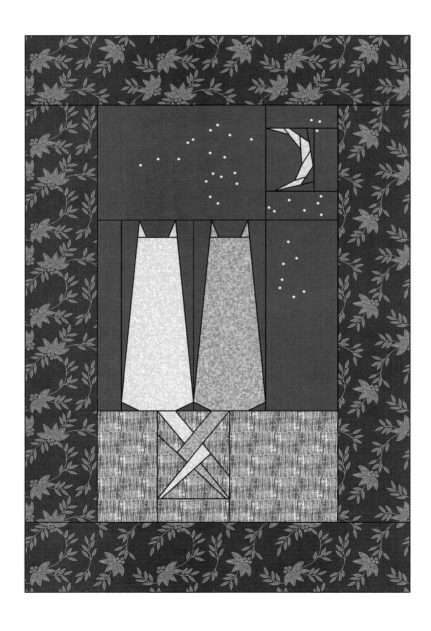

Fabric	Piece	No. of Pieces	Dimensions
Background	R	1	1½" x 3½"
	S	1	3" x 5¼"
	T	1	5" x 5¼"
	U	1	1½" x 8¾"
	V	1	3½" x 8¾"
	W	1	1½" x 3¼"
	X	1	1½" x 3½"
	Y	1	1¾" x 3½"
	Z	1	5½" x 7½"
Border	Sides	2	3½" x 18½"
	Top and bottom	2	3½" x 16½"

MATERIALS: *42"-wide fabric*

¼ yd. each OR scraps for 2 cats

Scraps for moon

½ yd. for background

¾ yd. for border and binding

¾ yd. for backing

Gold or silver seed beads

CUTTING

NOTE: Referring to the chart above, cut the pieces listed from the background fabric first, then use the remaining fabric to foundation-piece the block.

PIECING THE BLOCKS

Refer to "Foundation Piecing" on pages 5–8. Use the patterns on pages 60–61 and page 65. Press all seam allowances in the direction of the arrows unless otherwise instructed.

1. Foundation-piece 2 of cat body A from the pattern on page 60. Don't sew the pair of cat bodies together yet; wait until after you piece the tail sections together to be sure you put each cat on the correct side.

2. Make 1 entwined-tail unit from the patterns on page 61. Piece tail section C, then piece section D. Sew sections C and D together to make a C/D unit. Trim the C/D unit to 3½" x 4¼".

3. Sew background R to the bottom of the C/D unit.

4. Sew background pieces S and T to the sides of the C/D unit.

5. Sew the 2 cat bodies together, checking them against the C/D unit to put the cats in the correct position. Trim and press the seam allowances open. Trim the cat-body unit to 6½" x 8¾".

Tip

If you use a solid black fabric for your background, make several long chalk lines on your fabric parallel to the selvages. Cut your background pieces so the chalk lines always run side to side. Most solid blacks have a nap, and pieces with the lengthwise grain line running up and down will be a different color than pieces with the lengthwise grain line running side to side. You can see this most easily if you lay the fabric out and turn back one corner so the edge makes a 45° angle; then look at the fabric with a strong side light.

6. Sew background pieces U and V to the sides of the cat-body unit as shown.

7. Sew the tail section to the body section, matching raw edges and using a ¼"-wide seam allowance. Match the center arrow on the C/D unit to the center seam of the cats, and match the side arrows on the C/D unit to the corresponding arrows on 1 side of each cat body.

8. Foundation-piece the moon. Trim to 2" x 2¾".

9. Add background pieces W, X, and Y to the side, top, and bottom of the moon as shown.

10. Add background piece Z. Remove the moon foundation paper.

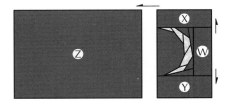

11. Sew the moon section to the cat section. Remove the cat foundation paper.

Assembling the Quilt Top

Sew the border strips to the sides first, then to the top and bottom edges of the quilt top; press the seam allowances toward the border.

Finishing the Quilt

1. Baste together the quilt top, batting, and backing.

2. Quilt around each cat, around the moon, and in-the-ditch on the inside edge of the border.

3. Sew gold or silver seed beads to the background for stars, sewing some of the beads through all layers.

4. Bind the edges of the quilt with ½"-wide binding.

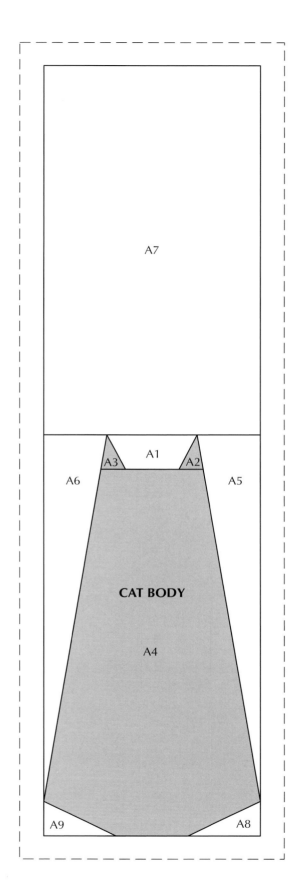

A7

A1

A3

A2

A6

A5

CAT BODY

A4

A9

A8

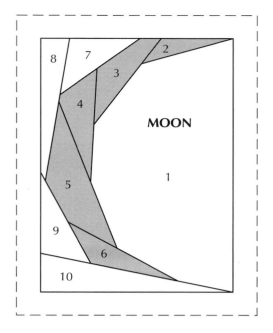

8

7

2

3

4

MOON

1

5

9

6

10

Note: Sections A and B on this page are options
you can use in the "Create-a-Cat" on page 60
or in a design of your choice.

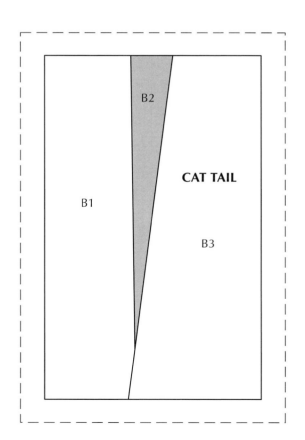

B2

CAT TAIL

B1

B3

Fetching

These young retrievers are the centers of Log Cabin blocks. With only one round of logs, this looks more like a dog quilt with fancy sashing strips than a traditional straight-furrows Log Cabin quilt.

Color Photo: page 24
Quilt Size: 34½" x 36"
Finished Block Size: 6" x 4½"

CUTTING

Fabric	Piece	No. of Pieces	Dimensions
Light Logs	Log 1	12	1¼" x 6½"
	Log 2	12	1¼" x 5¾"
Dark logs	Log 3	12	1¼" x 7¼"
	Log 4	12	1¼" x 6½"
Inner border	Top and bottom	2	1" x 23"
	Sides	2	1" x 25½"
Outer border	Top and bottom	2	5½" x 24"
	Sides	2	5½" x 35½"

MATERIALS: *42"-wide fabric*

½ yd. total OR scraps for retrievers

Scraps of dark fabrics for ears and noses

⅜ yd. OR scraps for light logs

⅜ yd. OR scraps for dark logs

¾ yd. for background

¼ yd. for inner border

1¼ yds. for outer border

1¼ yds. for backing

½ yd. for binding

Embroidery floss, beads, or fabric paint
for eyes

PIECING THE BLOCKS

Refer to "Foundation Piecing" on pages 5–8. Use the patterns on page 69. Press all seam allowances in the direction of the arrows unless otherwise instructed.

1. Foundation-piece 12 retrievers, 6 plus 6 reversed. Use darker fabrics for the ears and noses.

2. Sew the logs in order to the right-facing retrievers. After each seam, press the seam allowance toward the log before adding the next log. After all 4 logs have been added, remove the foundation paper. Make 6 of Block A.

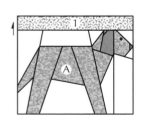

3. Sew the logs in order to the left-facing retrievers. After each seam, press the seam allowance toward the log before adding the next log. After all 4 logs have been added, remove the foundation paper. Make 6 of Block B.

ASSEMBLING THE QUILT TOP

1. Arrange the 12 blocks, alternating A and B blocks.

B	A	B
A	B	A
B	A	B
A	B	A

2. Sew the blocks together into 4 rows.

3. Sew the rows together to make the quilt top.

4. Sew the inner border strips to the top and bottom first, then to the side edges of the quilt top; press the seam allowances toward the inner border.

5. Sew the outer border strips to the top and bottom first, then to the side edges of the quilt top; press the seam allowances toward the outer border.

FINISHING THE QUILT

1. Baste together the quilt top, batting, and backing.

2. Quilt in diagonal lines.

3. Bind the edges of the quilt with ½"-wide binding.

4. Embroider, paint, or sew on beads for the eyes (see "Adding Faces and Other Details" on page 13).

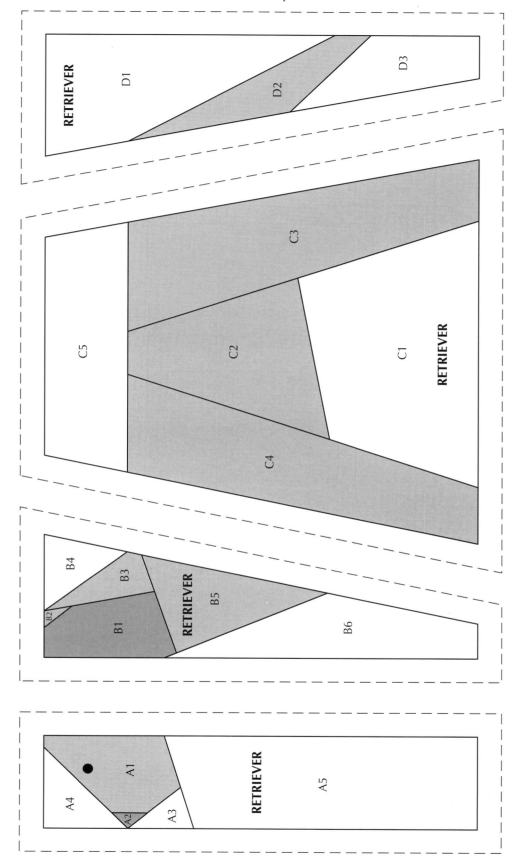

In the Doghouse

These special doghouses must be for special dogs. There are four different designs, all easy to sew. Because the piecing lines of the doghouses are simple, you can use geometric and directional prints and plaids.

Color Photo: page 24
Quilt Size: 31½" x 22"
Finished Block Sizes
 Doghouse W: 6" x 5"
 Doghouse X: 4½" x 4"
 Doghouse Y: 6" x 7½"
 Doghouse Z: 4" x 7½"
 Retriever: 6" x 4½"

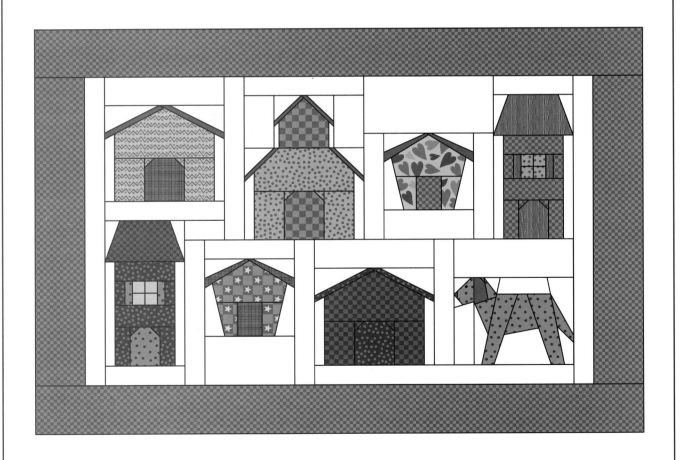

Fabric	Piece	No. of Pieces	Dimensions
Background	A	1	1½" x 5"
	B	1	3" x 5"
	C	2	1½" x 8"
	D	1	2" x 6½"
	E	1	2½" x 6½"
	F	1	1½" x 7"
	G	1	1½" x 13½"
	H	1	1½" x 2½"
	I	1	1½" x 4½"
	J	1	2" x 6½"
	K	1	1½" x 6½"
	L	1	1½" x 6½"
	M	1	1½" x 9"
	N	2	1½" x 6"
	O	1	3½" x 7"
	P	1	2" x 5"
	Q	1	1½" x 4½"
	R	2	1½" x 16½"
Border	Sides	2	3" x 16½"
	Top and bottom	2	3" x 31"

MATERIALS: *42"-wide fabric*

⅜ yd. total OR scraps for houses

¼ yd. OR scraps for dog

¾ yd. for background

¾ yd. for border and binding

¾ yd. for backing

CUTTING

NOTE: Referring to the chart above, cut background pieces A–R first, then use the remaining fabric to foundation-piece the blocks. As you cut the pieces, stack them in order, with piece A on top.

PIECING THE BLOCKS

Refer to "Foundation Piecing" on pages 5–8. Use the patterns on pages 69 and 73–76.

1. Foundation-piece 2 of Doghouse W, 2 of Doghouse X, 1 of Doghouse Y, and 2 of Doghouse Z.

2. For each Doghouse Z, you need 1 A/C foundation and 1 B foundation. Foundation-piece section A and set aside. Foundation-piece section B. Sew section B to the A/C foundation. Trim the seam allowances of this seam, remove the foundation paper in the seam allowances, and press. Pin section B to the A/C foundation to anchor it in place, then add the C pieces.

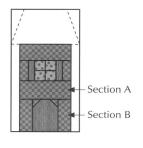

Section C

Section A

Section A

Section B

Doghouse Z

3. Using the retriever pattern on page 69, foundation-piece 1 dog reversed.

ASSEMBLING THE QUILT TOP

Because the size and spacing of the doghouses are irregular, the quilt is assembled in sections. Follow the directions step by step. Check the measurements of each background piece against the cutting chart to be sure you have the correct piece at each step. Press all the seam allowances toward the background strips and rectangles.

1. The first section includes a Doghouse X, a Doghouse W, the Retriever block, and background pieces A–G. Assemble as shown. Remove the foundation paper.

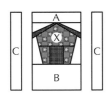
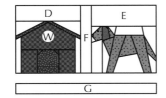

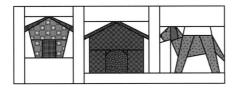

2. To the top left corner of this section, sew background piece H. This is a partial seam; sew it only about 1½", starting at the left edge.

3. Sew background piece I to the bottom of a Doghouse Z. Sew this to the larger unit to complete the bottom row of blocks. Remove the foundation paper from Doghouse Z.

Sew seam between arrows.

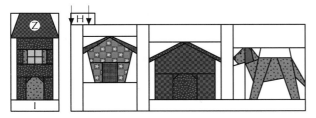

4. Sew background pieces J and K to the top and bottom of the remaining Doghouse W to make the left end unit of the top row. Remove the foundation paper. Sew this unit to the left end of the bottom row, matching the edges.

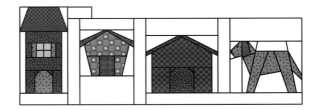

5. Assemble the remaining houses and background sections L–Q as shown. Remove the foundation paper.

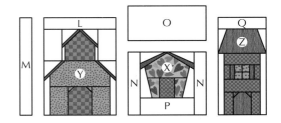

6. Complete the top row of blocks by sewing background piece M to Doghouse W.

7. Sew the top row to the bottom row, starting at the end of the partial seam started in step 2.

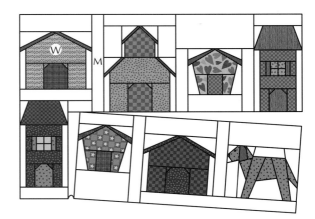

8. Sew the 2 background pieces R to the sides of the quilt top.

9. Sew the border strips to the sides first, then to the top and bottom edges of the quilt top; press the seam allowances toward the border.

FINISHING THE QUILT

1. Baste together the quilt top, batting, and backing.

2. Quilt around each house and the retriever.

3. Bind the edges of the quilt with ½"-wide binding.

4. Embroider, paint, or sew on a seed bead for the retriever's eye (see "Adding Faces and Other Details" on page 13).

5. Add buttons or other embellishments if desired. I sewed dog-bone buttons and fabric stars to the quilt "In the Doghouse."

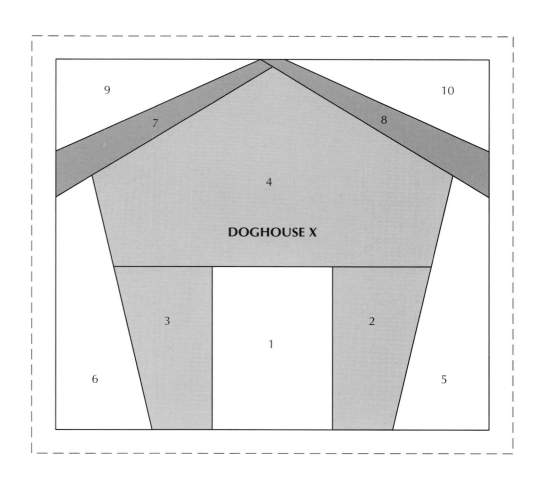

DOGHOUSE X

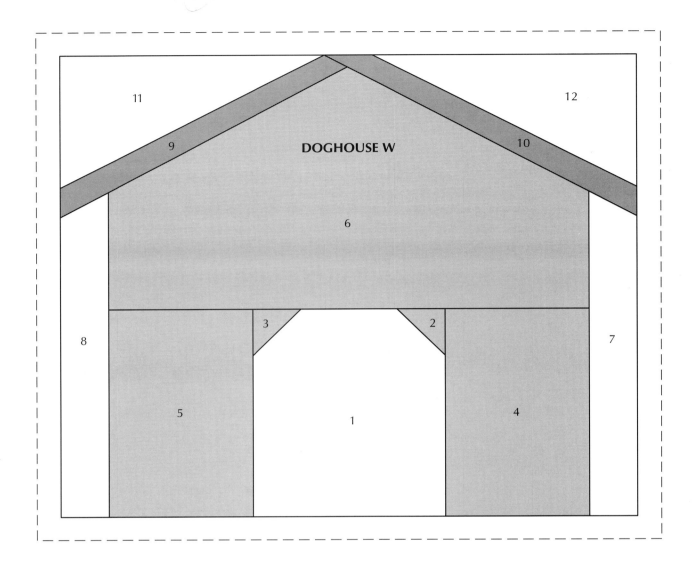

DOGHOUSE W

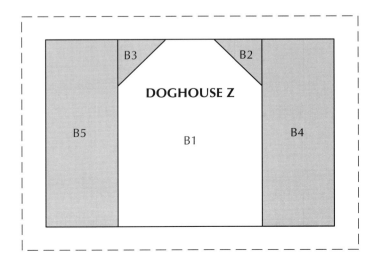

DOGHOUSE Z

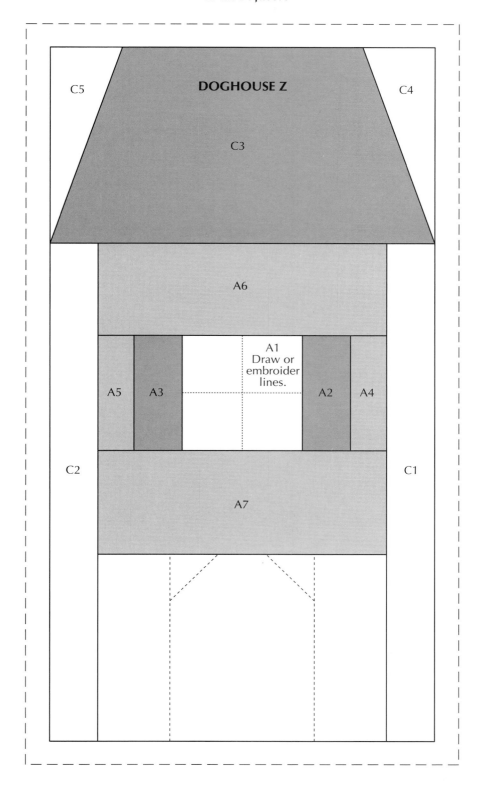

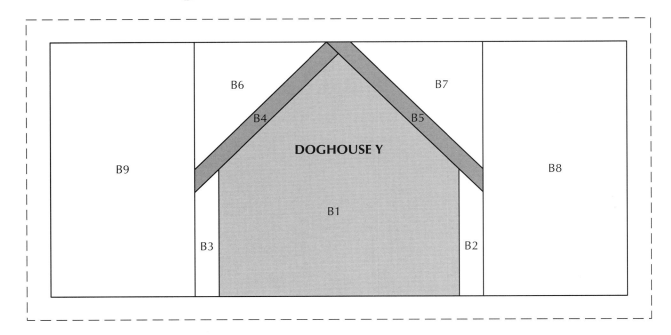

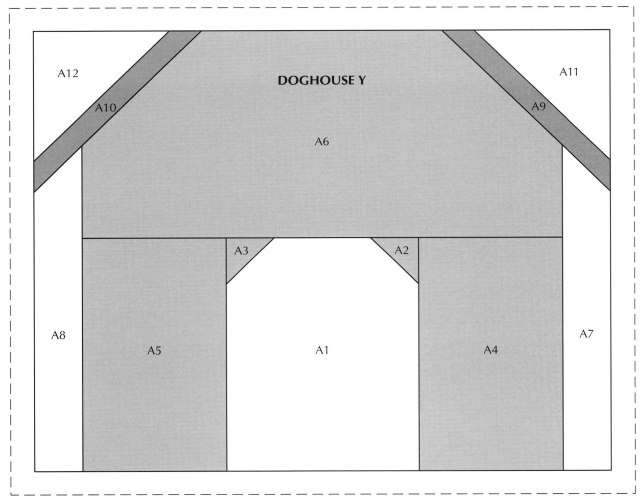

Wild Cats

These prowling cats and their fantasy stars are fun to piece—especially the stars, where you can really let yourself go.

Color Photo: page 25
Quilt Size: 38" x 35"
Finished Block Sizes
 Cats: 9" x 6"
 Stars: 9" x 9"

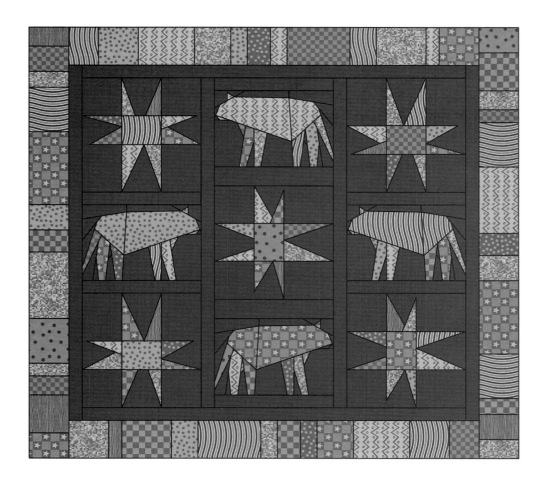

Fabric	Piece	No. of Pieces	Dimensions
Background	Horizontal sashing	6	1½" x 9½"
	Horizontal sashing	2	2" x 9½"
	Vertical sashing	2	1½" x 26½"
	Top and bottom inner border	2	1½" x 29½"
	Side inner border	2	1½" x 28½"
	Star A	10	3½" x 4¼"
	Star B	10	3½" x 3½"
Star	Star centers	5	2¾" x 3½"

MATERIALS: *42"-wide fabric*

1¼ yds. total for cats, stars, and border

1¾ yds. for background and binding

1⅛ yds. for backing

CUTTING

NOTE: Referring to the chart above, cut the sashing and border strips, star pieces, and binding strips (if desired) from the background fabric first, then use the remaining fabric to foundation-piece the blocks.

PIECING THE BLOCKS

Refer to "Foundation Piecing" on pages 5–8. Use the patterns on pages 79–81.

Wildcat Blocks

1. Foundation-piece 4 cats, 2 plus 2 reversed. Sew section A to section B, then section C to the A/B unit. Match carefully and pin at the arrows, where the top of the cat's back should form one smooth line. In the "WildCats" quilt, pieces A1, B1, B9, and C8 were cut from the same fabric.

2. Staystitch around each block, ⅛" from the outer edges. Remove the foundation paper.

Star Blocks

1. Foundation-piece 5 stars. Each star requires 4 foundation-pieced sections: 1 each of X, Y1, Y2, and Z. Trim each section, leaving a ¼"-wide seam allowance. Leave the foundation paper in.

2. Assemble the Star block from the foundation-pieced sections, background pieces A and B, and the star center piece. Remove the foundation paper.

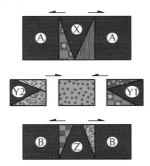
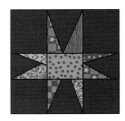

Make 5.

ASSEMBLING THE QUILT TOP

1. Arrange the WildCat and Star blocks as shown in the quilt diagram, in 3 vertical rows.

2. Sew 1½" x 9½" sashing strips between the blocks in the first and third vertical rows. Sew the 2" x 9½" sashing strips between the blocks in the

center row. Sew the last two 1½" x 9½" sashing strips to the top and bottom of the center row.

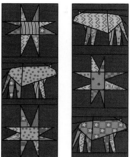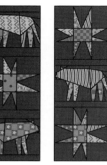

3. Sew the vertical sashing strips between the vertical rows, then sew the rows together. Press the seam allowances toward the sashing strips.

4. Sew the inner border strips to the top and bottom first, then to the side edges of the quilt top; press the seam allowances toward the inner border.

5. To make the outer border, cut pieces of the cat and star fabrics 3½" wide and in a variety of lengths from 2" to 5".

6. Sew pieces together to make the top and bottom borders, each 31½" long. Sew the border strips to the quilt top and bottom; press the seam allowances toward the inner border.

7. Sew pieces together to make the side borders, each 34½" long. Sew the border strips to the quilt top; press the seam allowances toward the inner border.

FINISHING THE QUILT

1. Baste together the quilt top, batting, and backing.

2. Quilt around each cat and star. Quilt in-the-ditch on the inner edge of the outer pieced border.

3. Bind the edges of the quilt with ½"-wide binding.

CREATE-A-STAR

You can be wild and crazy with the irregular stars. Move the lines of the star points around, but keep the points pointy. You can also make the center larger or smaller, or move it more off-center to make the block even more asymmetrical.

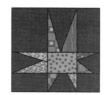

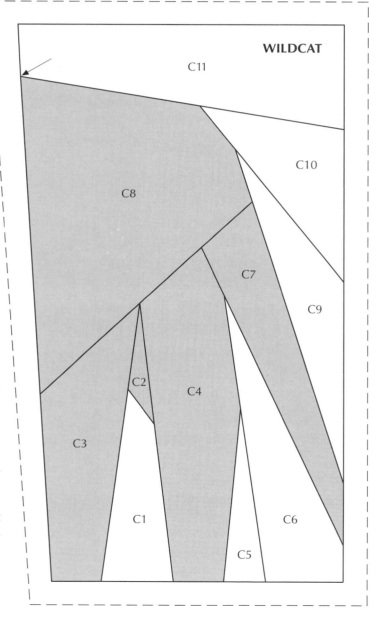

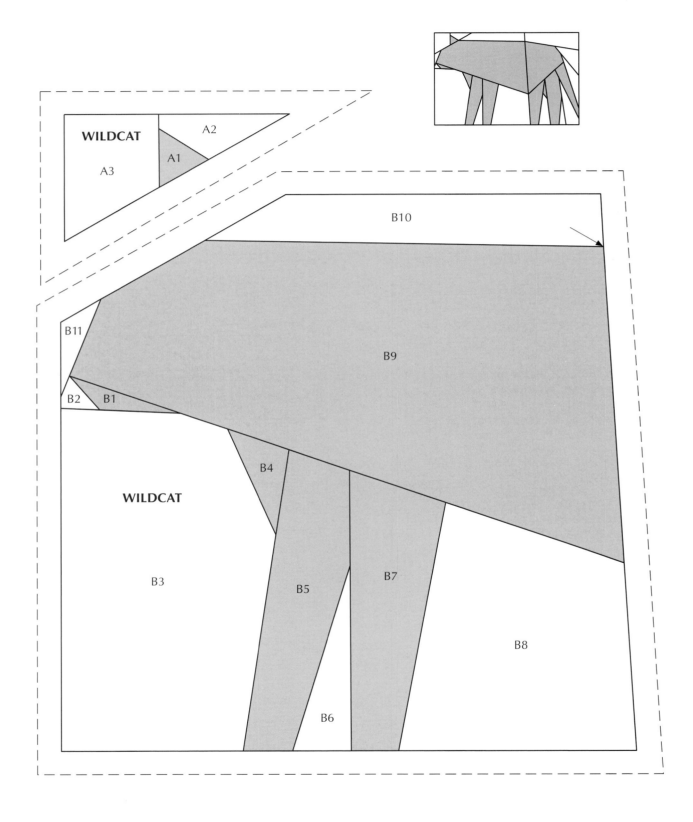

WILDCAT

A2

A1

A3

B10

B11

B9

B2 B1

B4

WILDCAT

B3

B5

B7

B8

B6

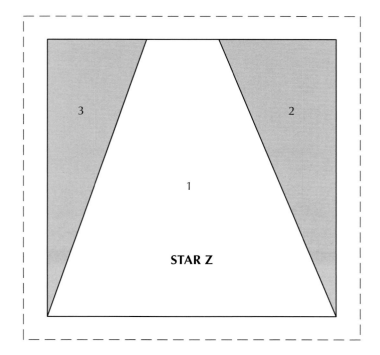

STAR Z

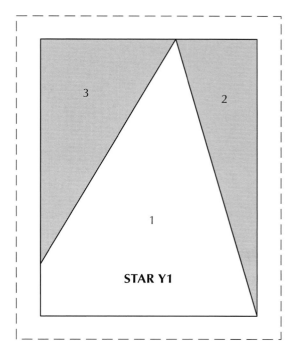

STAR Y1

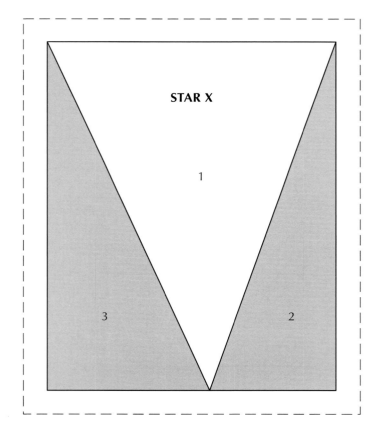

STAR X

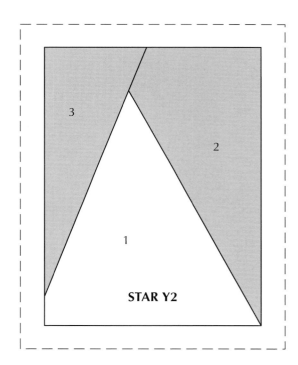

STAR Y2

Chasing the Ball

These happy dachshunds are foundation-pieced, then triangles are added to all four sides to tilt the dogs up or down. Strip-piece the balls, or look for fabric with bright stripes.

Color Photo: page 27
Quilt Size: 26" x 24"
Finished Block Sizes
 Dachshund (before outer
 triangles are added): 6" x 2"

 Dachshund (after outer
 triangles are added): 6½" x 3"

 Ball: 2" x 3"

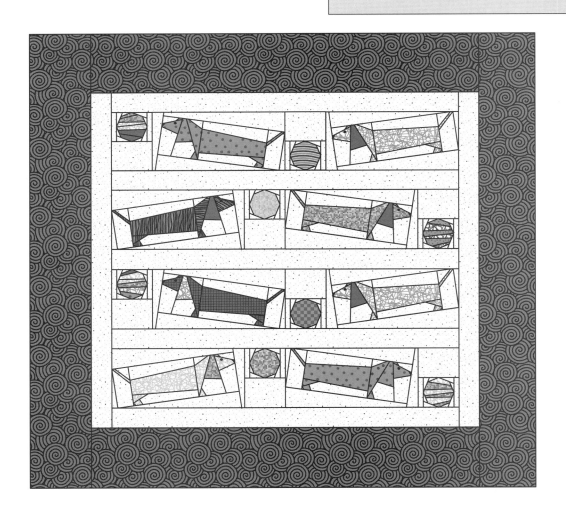

Fabric	Piece	No. of Pieces	Dimensions
Background	Horizontal sashing	3	1½" x 17½"
	Top and bottom inner border	2	1½" x 17½"
	Side inner border	2	1½" x 17½"
Outer Border	Top and bottom	2	3½" x 19½"
	Sides	2	3½" x 23½"

MATERIALS: *42"-wide fabric*

¼ yd. total OR scraps for dachshunds

Scraps of dark fabrics for ears and noses

1 yd. for background

¾ yd. for outer border and binding

⅞ yd. for backing

Embroidery floss, seed beads, fine-tip permanent pen, and/or fabric paint for eyes and noses

CUTTING

NOTE: Referring to the chart above, cut the sashing and inner border strips from the background fabric first, then use the remaining fabric to foundation-piece the blocks.

PIECING THE BLOCKS

Refer to "Foundation Piecing" on pages 5–8. Use the patterns on pages 84–85. Press all seam allowances in the direction of the arrows unless otherwise instructed. You will need 1 each of foundation patterns A, B, C, D, and E for each dachshund. Set aside E for step 2.

1. Foundation-piece 8 dachshunds, 4 plus 4 reversed. Use darker fabrics for the ears. Sew together sections A, B, C, and D.

2. Position the pieced dachshund on pattern E, using pins to match the 4 corners of the dachshund with the matching 4 corners on pattern E. Pin the pieced dachshund to foundation pattern E

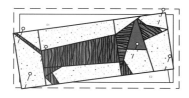

to anchor it in place, then foundation-piece E. Make 4 dogs running up and 4 dogs running down.

3. Foundation-piece 8 balls. Follow the stitching lines on the pattern, or make up your own stitching lines for the stripes. Or, use the simpler ball foundation pattern, and use a striped or checked fabric for the ball.

ASSEMBLING THE QUILT TOP

1. Following the quilt diagram on page 82, sew the dachshund and ball blocks together into 4 rows. Staystitch around each row, ⅛" from the outer edges. Remove the foundation paper.

2. Sew the 4 rows together, adding a 17½" sashing strip between each row. Press the seam allowances toward the sashing strips.

3. Sew the inner border strips to the top and bottom first, then to the side edges of the quilt top; press the seam allowances toward the inner border.

4. Sew the outer border strips to the top and bottom first, then to the side edges of the quilt top; press the seam allowances toward the outer border.

FINISHING THE QUILT

1. Baste together the quilt top, batting, and backing.

2. Quilt in wavy lines or as desired.

3. Bind the edges of the quilt with ½"-wide binding.

4. Embroider the noses, paint on with fabric paint, or ink with a fine-tip permanent pen. Embroider, paint, or sew on seed beads for the eyes (see "Adding Faces and Other Details" on page 13).

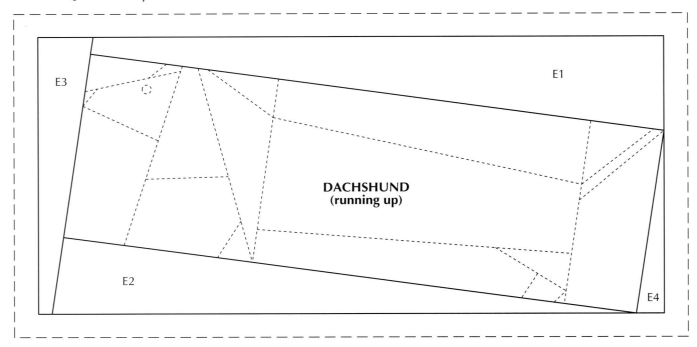

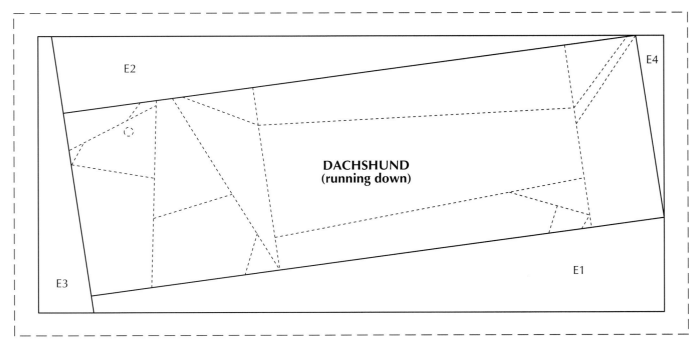

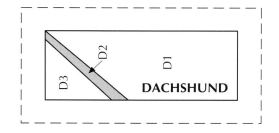

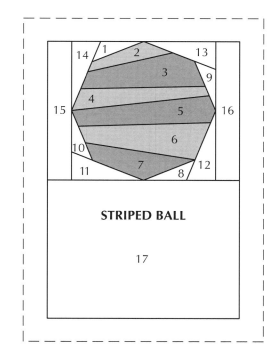

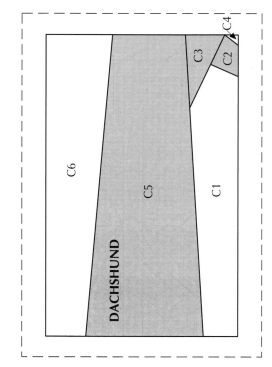

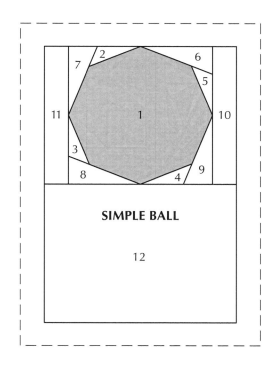

Sit Up and Beg

When my mother first saw the Dachshund block, she said, "They should be sitting up and begging." And here they are, in a miniature quilt. The dachshund is just like the dog in "Chasing the Ball" on page 82, except for the position of the tail.

Color Photo: page 27
Quilt Size: 12½" x 13¼"
Finished Block Sizes
 Dachshund (before outer triangles are added): 5¼" x 2

 Dachshund (after outer triangles are added): 4" x 5½"

 Dog Bone: ¾" x 1½"

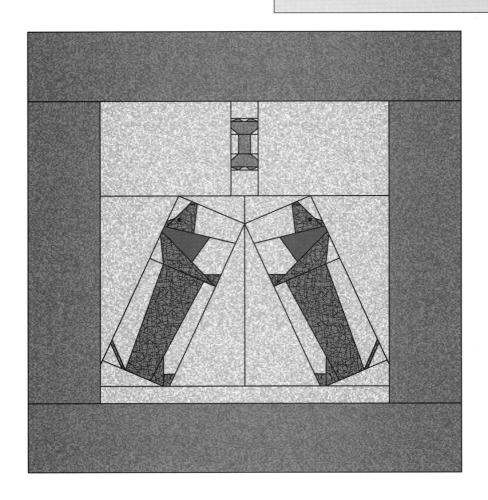

Fabric	Piece	No. of Pieces	Dimensions
Background	W	1	1" x 8½"
	X	1	1" x 1¼"
	Y	1	1¼" x 1¼"
	Z	2	3¼" x 4⅛"
Border	Sides	2	2½" x 9¼"
	Top and bottom	2	2½" x 12½"

MATERIALS: *42"-wide fabric*

Scraps for dachshunds and dog bone

Scraps of dark fabrics for ears

¼ yd. for background

¼ yd. for border

¼ yd. for binding

½ yd. for backing

Black embroidery floss, seed beads, fine-line permanent pen and/or fabric paint for eyes and noses

CUTTING

NOTE: Referring to the chart above, cut the background pieces listed first, then use the remaining fabric to foundation-piece the blocks.

PIECING THE BLOCKS

Refer to "Foundation Piecing" on pages 5–8. Use the patterns on pages 88–89. Press all seam allowances in the direction of the arrows unless otherwise instructed.

1. You will need 1 each of foundation patterns A, B, C, and D for each dachshund. Set aside D for step 2. Foundation-piece 2 dachshunds, 1 plus 1 reversed. Use dark fabrics for the ears. Sew together sections A, B, and C.

2. Position the pieced dachshund on pattern D, using pins to match the 4 corners of the dachshund with the matching 4 corners on pattern D. Pin the pieced dachshund to foundation pattern D to anchor it in place, then foundation-piece D.

3. Foundation-piece 1 dog bone.

ASSEMBLING THE QUILT TOP

1. Sew background pieces X and Y to the top and bottom of the dog bone.

2. Sew a background Z to each side of the dog-bone unit.

3. Sew the 2 Dachshund blocks together so the dachshunds face each other as shown on page 88.

4. Sew the narrow background strip W to the bottom of the dachshund section.

5. Sew the dog-bone unit to the dachshund unit.

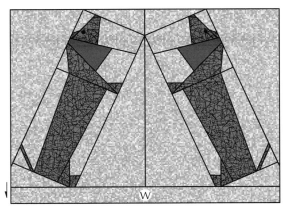

6. Sew the border strips to the sides first, then to the top and bottom edges of the quilt top; press the seam allowances toward the border.

7. Remove the foundation paper.

FINISHING THE QUILT

1. Baste together the quilt top, batting, and backing.

2. Quilt around the dachshunds and the dog bone. Quilt in-the-ditch just inside the border.

3. Bind the edges of the quilt with ¼"-wide binding.

4. Embroider the noses, paint them with fabric paint, or ink them with a fine-tip permanent pen. Embroider, paint, or sew on seed beads for the eyes (see "Adding Faces and Other Details" on page 13).

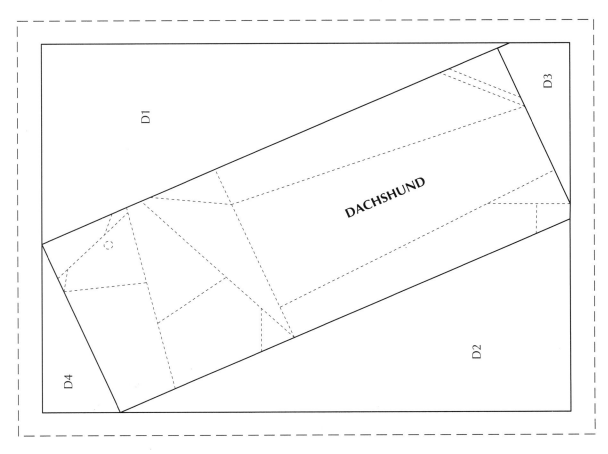

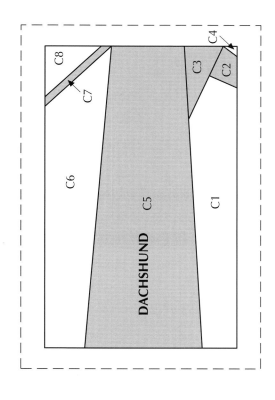

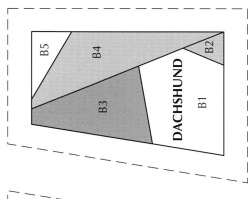

DOG BONE

Linus and Samantha

Foundation-pieced morning glory vines make a graceful wreath around these two cats.

Color Photo: page 28
Quilt Size: 31" x 22"
Finished Block Sizes
 Cat: 6" x 9"
 Morning Glory: 2¼" x 4½"

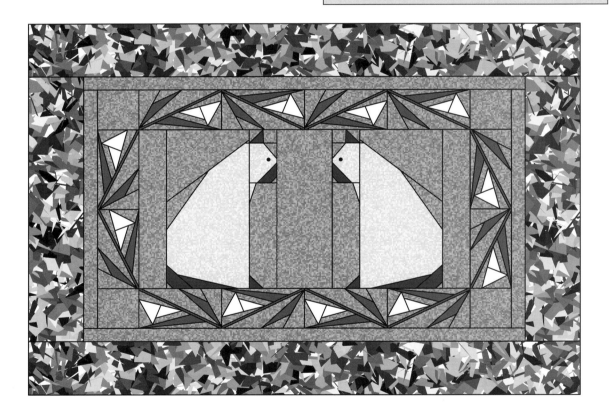

Fabric	Piece	No. of Pieces	Dimensions
Background	A	1	3½" x 9½"
	B	2	2" x 9½"
	C	4	2¾" x 2¾"
	Side inner border	2	1¼" x 14"
	Top and bottom inner border	2	1¼" x 24½"
Outer Border	Sides	2	3½" x 15½"
	Top and bottom	2	3½" x 30½"

MATERIALS: *42"-wide fabric*

¼ yd. *each* of 2 fabrics for cats

Scraps of 2 dark accent fabrics for cats

¼ yd. for morning glory vines

¼ yd. for stems and leaves

1 yd. for background

⅞ yd. for borders and binding

⅞ yd. for backing

Embroidery floss, fabric paint, or beads
 for cats' eyes

CUTTING

NOTE: Referring to the chart above, cut the squares, rectangles, and inner border strips from the background fabric first, then use the remaining fabric to foundation-piece the blocks.

PIECING THE BLOCKS

Refer to "Foundation Piecing" on pages 5–8. Use the patterns on pages 94–95. Press all seam allowances in the direction of the arrows unless otherwise instructed.

1. Foundation-piece 1 cat and 1 cat reversed. For Siamese markings, use a dark fabric for pieces A3, B1, C3, D5, and D6 as indicated. For a non-Siamese cat, use 1 cat fabric for all except the tail pieces D5 and D6. Omit the nose piece A3, using instead 1 larger piece of cat fabric to cover areas A1 and A3. (If desired, the tail can also be deleted; use 1 larger piece of cat fabric to cover areas D1, D5, and D6.)

2. Foundation-piece 12 morning glories, 6 plus 6 reversed.

ASSEMBLING THE QUILT TOP

1. Sew background piece A between the 2 Cat blocks.

2. Sew the 2 background B pieces to the sides of the cat unit.

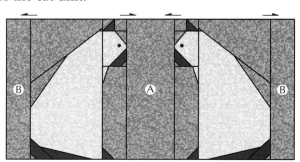

3. Sew 2 Morning Glory blocks together end to end to make each of the 2 side border strips. Refer to the quilt diagram for the orientation of each block. Sew the side Morning Glory border strips to the cat unit.

4. Sew 4 Morning Glory blocks together end to end to make the top and bottom border strips. Refer to the quilt diagram for the orientation of each block. Sew a background square C to each end of both border strips.

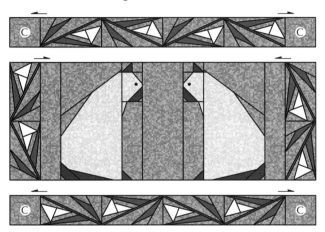

5. Sew the top and bottom Morning Glory border strips to the quilt top. Press the seam allowances toward the cats.

6. Sew the inner border strips to the sides first, then to the top and bottom edges of the quilt top; press the seam allowances toward the inner border.

7. Sew the outer border strips to the sides first, then to the top and bottom edges of the quilt top; press the seam allowances toward the outer border.

Finishing the Quilt

1. Baste together the quilt top, batting, and backing.

2. Quilt a heart between the 2 cats, using the heart template on this page, then quilt around each cat. Referring to the lines on D1, quilt lines on the cats to make the front and back legs. Quilt down the centers of the stems all around the Morning Glory border. Quilt just inside the outer border. If desired, quilt the outer border.

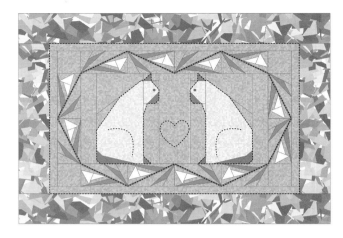

3. Bind the edges of the quilt with ½"-wide binding.

4. If desired, embroider, paint, or sew on beads for the eyes (see "Adding Faces and Other Details" on page 13).

Linus and Samantha
Heart Quilting Template

CREATE-A-BORDER

The Morning Glory vine border of this quilt can be made smaller to circle one block, as in "Sophis-T-Cat" (page 28), or larger as in the samples shown here. To maintain the design, there must be an even number of Morning Glory blocks on each side of the quilt. Since the blocks are 4½" long, this allows sides of 9" (2 blocks), 18" (4 blocks), 27" (6 blocks), and so on. Or, you can use a photocopier to enlarge or reduce the Morning Glory block to whatever size fits your quilt.

MORNING GLORY

4
3
5
2
1
6
8
9
7
11
10
12

C2

SIAMESE CAT

C1

C3

SIAMESE CAT

A2
A1
A3
A4

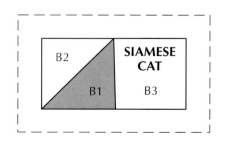

B2
B1
SIAMESE CAT
B3

Hanging BasKats

Use two fabrics for each kitten: one fabric for the head and paws, and a lighter fabric for the tummy and toe pads. Look for a print that looks woven for the basket fabric.

Color Photo: page 29
Quilt Size: 24" x 28"
Finished Block Size: 6" x 8½"

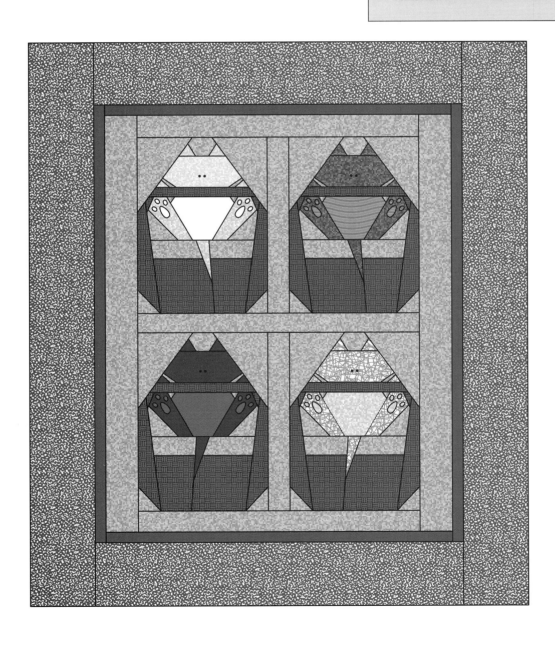

Fabric	Piece	No. of Pieces	Dimensions
Background	Vertical sashing	2	1½" x 9"
	Horizontal sashing	1	1½" x 13½"
	Top and bottom inner border	2	1½" x 13½"
	Side inner border	2	2" x 20½"
Accent	Top and bottom	2	1" x 16½"
	Sides	2	1" x 21½"
Border	Top and bottom	2	3½" x 17½"
	Sides	2	3½" x 27½"

MATERIALS: *42"-wide fabric*

¼ yd. total OR scraps for kittens

¼ yd. total OR scraps for kitten tummies and toe pads

¼ yd. total for baskets

¾ yd. for background

¼ yd. for accent strip

1 yd. for outer border and binding

⅞ yd. for backing

Embroidery floss, beads, or fabric paint for eyes

Embroidery floss, fusible web, or fabric paint for toe pads

CUTTING

NOTE: Referring to the chart above, cut the sashing and inner border strips from the background fabric first, then use the remaining fabric to foundation-piece the blocks.

PIECING THE BLOCKS

Refer to "Foundation Piecing" on pages 5–8. Use the patterns on pages 96–100. Make 4 blocks, 2 with sections C and D reversed.

NOTE: The E pieces do not have a separate foundation pattern; they are added after units A, B, C, and D are sewn together. For each cat, you will need 1 of the A/E foundation pattern on page 99, plus the foundation patterns for sections B, C, and

D on page 100. Do not cut apart the A/E foundation pattern.

1. Foundation-piece section A and set the A/E foundation pattern aside.

2. Foundation-piece section B. Note that pieces B8 and B9 are basket fabric.

3. Sew section B to section A, matching the center arrows. Trim the seam allowances, remove the paper foundation from the seam allowances only, and press. Pin section B to the A/E foundation to anchor it in place.

4. Foundation-piece sections C and D. Sew section C to section D.

5. Sew unit C/D to section B, again matching the center arrows. Trim the seam allowances, remove the paper from the seam allowances only and press. Pin unit C/D to the A/E foundation pattern to anchor it in place.

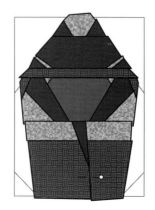

6. Foundation-piece section E.

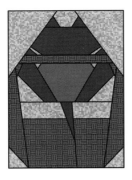

7. Trim the blocks. Staystitch around each block, ⅛" from the outer edges. Remove the foundation paper.

Assembling the Quilt Top

1. Arrange the 4 blocks. Sew a 1½" x 9" sashing strip between the top 2 cats, and sew another strip between the bottom 2 cats. Press the seam allowances toward the sashing strips.

2. Sew a 1½" x 13½" sashing strip between the 2 rows of cats. Press the seam allowances toward the sashing strip.

3. Sew the inner border strips to the top and bottom first, then to the side edges of the quilt top; press the seam allowances toward the inner border.

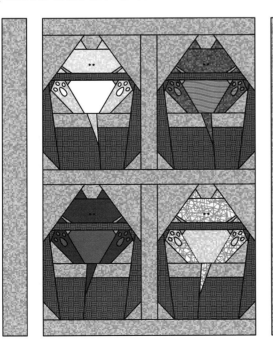

4. Sew the accent strips to the top and bottom first, then to the side edges of the quilt top; press the seam allowances toward the accent strips.

5. Sew the outer border strips to the top and bottom first, then to the side edges of the quilt top; press the seam allowances toward the outer border.

Finishing the Quilt

1. Baste together the quilt top, batting, and backing.

2. Quilt around each cat and basket. Quilt in-the-ditch on both sides of the accent strip.

3. Bind the edges of the quilt with ½"-wide binding.

4. Embroider, paint, or sew on seed beads for the eyes (see "Adding Faces and Other Details" on page 13).

5. Embroider the toe pads, paint with fabric paint, machine appliqué, or appliqué with fusible web, following the package directions.

Tip

You can decorate your baskets with Yo-yo flowers, as in "Mickie in the Flower Basket" (page 29). Using the Yo-yo templates on page 101, cut a circle of fabric for each flower. Turn under ⅛" and sew with a running stitch, pulling up the stitching as tightly as possible to gather the outer edges as you sew. Fasten off the thread. Place a button in the center of each Yo-yo and sew to the quilt, gathered side up.

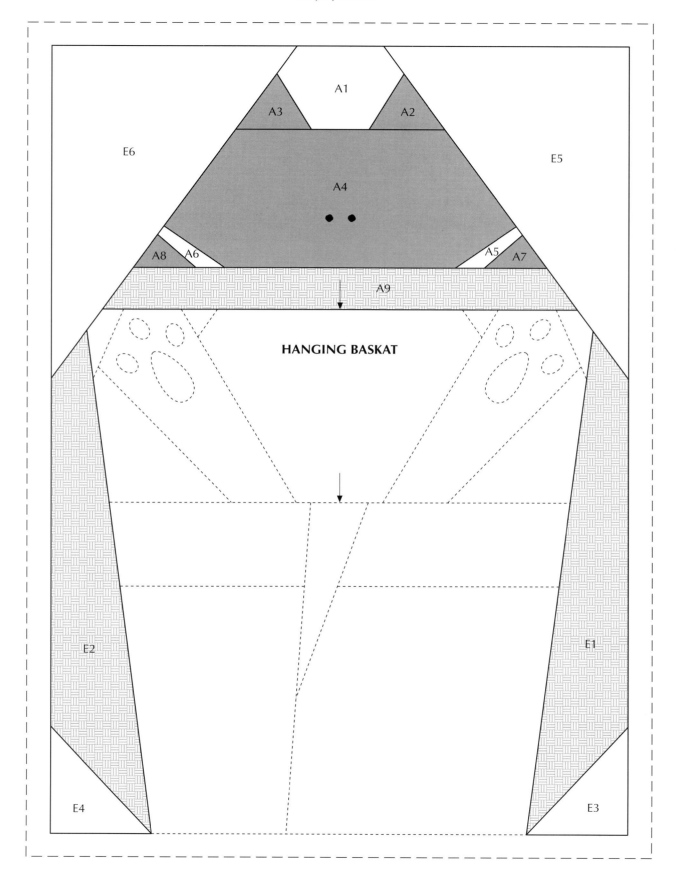

HANGING BASKAT

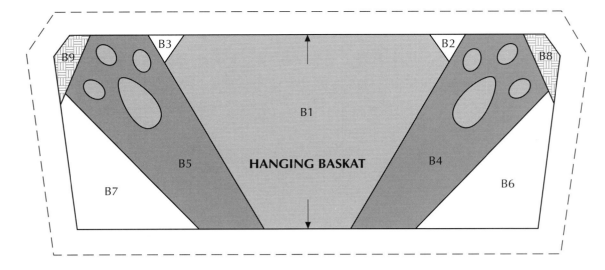

B9 B3 B2 B8

B1

B5 **HANGING BASKAT** B4

B7 B6

D2

HANGING BASKAT

D1

C3 C2

HANGING BASKAT

C1

Fold line

Large Yo-yo Template

Fold line

Small Yo-yo Template

Angels Who Meow on High

S titch these little angels up in Christmas colors for a holiday wall hanging.

Color Photo: page 30
Quilt Size: 21" x 21"
Finished Block Size: 6" x 6"

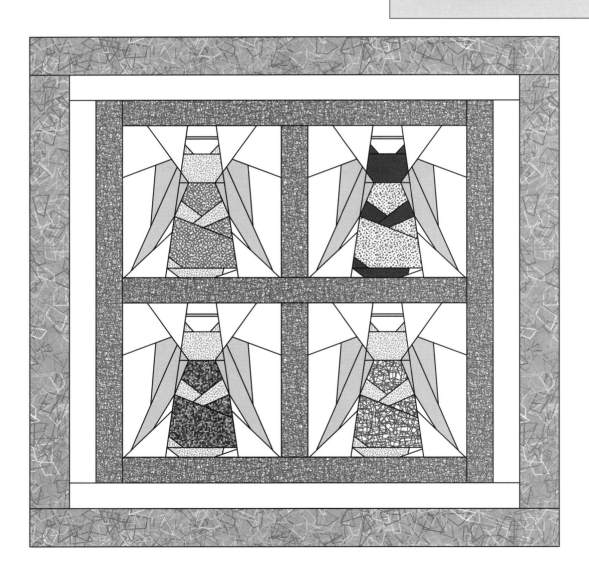

Fabric	Piece	No. of Pieces	Dimensions
Sashing	Vertical	2	1½" x 6½"
	Horizontal	3	1½" x 13½"
	Sides	2	1½" x 15½"
Background	Side inner border	2	1½" x 15½"
	Top and bottom inner border	2	1½" x 17½"
Outer Border	Sides	2	2" x 17½"
	Top and bottom	2	2" x 20½"

MATERIALS: *42"-wide fabric*

¼ yd. total OR scraps for cats

¼ yd. total OR scraps for angel dresses

¼ yd. total OR scraps for angel wings
and halos

½ yd. for background and inner border

¼ yd. for sashing and binding

¼ yd. for outer border

⅞ yd. for backing

CUTTING

NOTE: Referring to the chart above, cut the inner border from the background fabric first, then use the remaining fabric to foundation-piece the blocks.

PIECING THE BLOCKS

Refer to "Foundation Piecing" on pages 5–8. Use the patterns on page 105–106.

1. Foundation-piece 4 Angel blocks. In section A, note that A7 and A8 are wing fabric. In section B, note that B7 and B8 are also wing fabric, and B6 is cat fabric.

2. Sew section C to section B, then sew section A to B/C.

3. Foundation-piece the D wing sections. Sew the wings to the cat body, matching carefully and pinning at the arrows.

ASSEMBLING THE QUILT TOP

1. Lay out the 4 Angel blocks. Sew the top 2 angels together with a vertical sashing strip between. Repeat with the bottom 2 angels. Press the seam allowances toward the sashing strips.

2. Sew 1 of the horizontal sashing strips between the 2 rows of angels. Sew the other 2 horizontal strips to the top and bottom of the quilt top. Press the seam allowances toward the sashing strips.

3. Sew the side sashing strips to the sides of the quilt top. Press the seam allowances toward the sashing strips.

4. Remove the foundation paper.

5. Sew the inner border strips to the sides first, then to the top and bottom edges of the quilt top; press the seam allowances toward the inner border.

Tip

Matching points and pinning can be a problem when there is a lot of bulk from seam allowances; the two layers will shift as you push the pin back up. To avoid this shifting, push a pin straight through the matching points. Leaving the positioning pin in place, pin the seam on both sides, then remove the positioning pin.

6. Sew the outer border strips to the sides first, then to the top and bottom edges of the quilt top; press the seam allowances toward the outer border.

FINISHING THE QUILT

1. Baste together the quilt top, batting, and backing.

2. Quilt around each cat. Quilt in-the-ditch just inside the outer border. If desired, stipple-quilt the background.

3. Bind the edges of the quilt with ¼"-wide binding.

CREATE-A-CAT

∾ You can omit the cat's tail if you wish. Omit piece B6, and in place of section C, sew a 1"-wide strip of background fabric to the bottom edge of the dress.

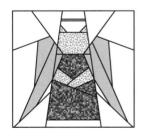

∾ You can simplify section B of the angel cat by omitting the front legs (pieces B2 and B3); make the dress from one piece of fabric. You may prefer this if you want the pattern of the dress fabric to show (to center a motif, for example) or if you want to use a stripe or plaid.

∾ Make country angels by stitching a heart to the front of the dress. Tilt the halo a little to make your angel a little less angelic.

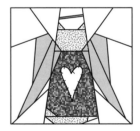

Tip

For extra fun, experiment with exotic fabrics. They are especially appealing in holiday quilts. There are wonderful metallics available, as well as laces (some of them metallic too) and silky fabrics.

Be very careful pressing exotic fabrics, as many of them melt easily. Experiment with samples. If you can't use heat, press each seam by running your thumbnail along it.

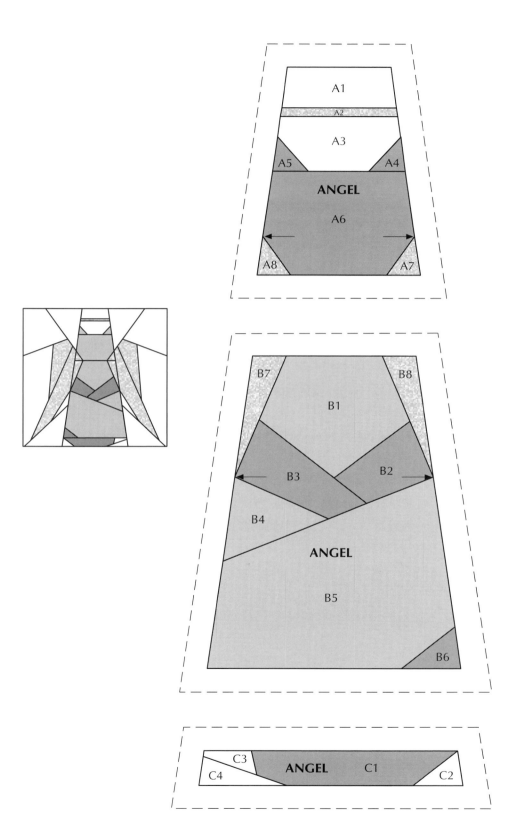